WATFORD IN 50 BUILDINGS

PAUL RABBITTS & PETER JEFFREE

AMBERLEY

About the Authors

Paul Rabbitts is Head of Parks for Watford Borough Council and has worked in the public sector for over thirty years. A qualified landscape architect, he moved to Leighton Buzzard in 2011 and has been a prolific author on public parks, the royal parks, the Victorian bandstand and has extended his interest in local history to architecture, including biographies on Decimus Burton and Sir Christopher Wren.

Peter Jeffree is a retired architect who now applies his architectural eye and his lifelong interest in photography to documenting important historic buildings before, during and after conservation or restoration. All the photographs are by Peter, who has lived in Watford for over forty years.

To the townsfolk of Watford who bring these buildings to life

First published 2019

Amberley Publishing, The Hill, Stroud
Gloucestershire GL5 4EP

www.amberley-books.com

British Library Cataloguing in Publication Data.
A catalogue record for this book is available from the British Library.

ISBN 978 1 4456 9012 4 (print)
ISBN 978 1 4456 9013 1 (ebook)

Typesetting by Aura Technology and Software Services, India.
Printed in Great Britain.

Contents

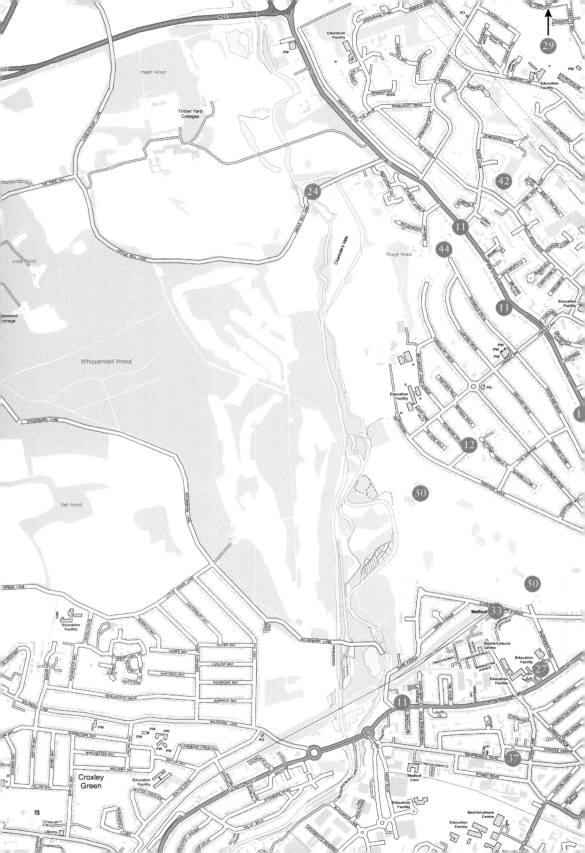

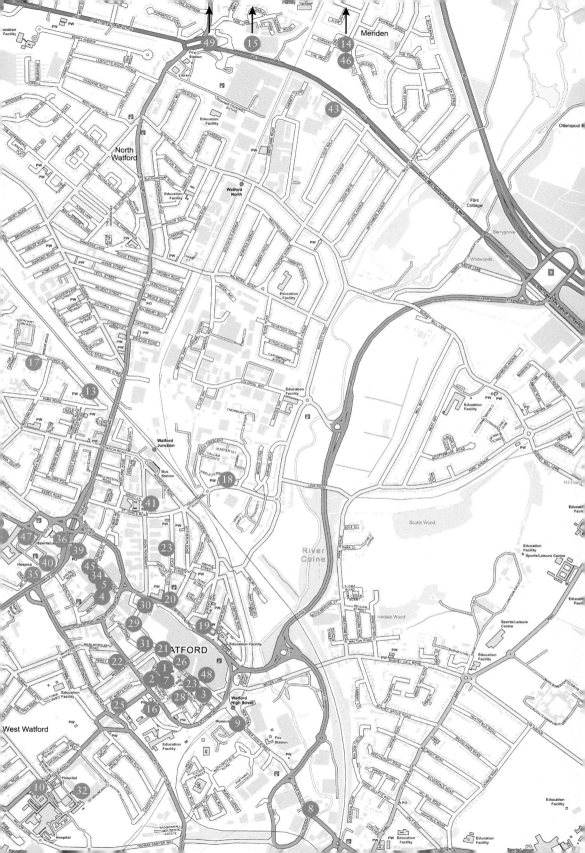

Key

Introduction

John Britton in 1806 describes Watford as 'a large, populous and busy town; the houses are principally brick; many of them are respectable handsome buildings; they principally range on the sides of the high road'. A further description of Watford just before the railway age was written by Eustace Conder, whose father lived at Watford Field House from 1824 to 1839:

> As the town lay several miles off the Great North Road, there was no great amount of traffic passing through. Two or three London coaches on their way to Chesham, Hampstead or some other town further down the country, were the modest substitute for long railway trains, with their two or three hundred passengers. A few lumbering carriers' and representing the goods trains of later and more impatient times. Every night, the mail coach, with its flaring eyes and red-coated guard, made the quiet streets echo with its horn, picked up, perhaps, its one passenger, and excited mysterious feelings of respect and wonder in the minds of little boys. All round the dear, dull, quiet little town lay the still more quiet country. Two minutes would bring you into it; on the one side across the little river Colne, into green low-lying meadows, which the artificially raised banks do not keep the stream from overflowing for miles after heavy rains; on the other, through the lime-shaded churchyard, out among cornfields and homesteads, and shady lanes; or over stiles and through footpaths, to where the deer browse amongst the spreading limes and beeches, or hide in the thickets of tall fern, in Cassiobury Park.

By 1891, Watford was described as 'quietly reposing in the lap of fairest England … bathe by sweet waters of the Colne, embowered in parks and woods, fertile and beautiful; … its climate so genial and healthful as to make existence a delight; … such is the Watford of today, grown out of a simple country town, into a large and thriving community, of some twenty thousand inhabitants'.

Forty years later, one of the most thorough historical books written about Watford was by W. R. Saunders, simply called *History of Watford*, which was originally published in 1931. Its introduction describes the 'thousands who have made their homes in the town within the last few years … and those older residents who have watched the growth of Watford from a small country town to a borough of over 56,000 inhabitants'. He goes on to say that his book 'disproves the statement sometimes made that "Watford has no history"'. Updated in 1969

by A. W. Ball, he reminds readers of Saunders' book that they will 'no longer remember the places described and the personalities discussed, but as they go about the town, they will be reminded by the façade of a building here or the twists and turns of a road there, that all progress is built on the efforts of the past'.

All descriptions are apt for their time but Watford since the Second World War has been constantly renewing itself. The Watford of today has a distinct identity, standing alone from rural Hertfordshire, different from many of the other towns in the county as well as being entirely separate from London. Its history goes back centuries and, although it wasn't mentioned in the Domesday Book, the manor of Cashio certainly was. Cassiobury has dominated Watford for many centuries, and up to a point it still does, but very differently today.

So we come to this book. This is not a history of Watford. There have been many books on this, most recently Mary Forsyth's *Watford: A History* in 2015, an excellent and recent straightforward history of the town and its people. This book is a celebration of its buildings and its architecture and, clearly, this involves the retelling of some of its history. Daniel Defoe described Watford as 'the town is very long, having but one street. A genteel market town' and many of its buildings reflect this. From the earliest buildings of the thirteenth, fourteenth and fifteenth centuries, Watford has evolved into a thriving, bustling town that still retains its market and has developed in many cases through its buildings, including places of entertainment that have come and gone, such as cinemas, theatres, public houses, to those that have replaced them, such as the football ground, the Colosseum and our leisure centres. The changes in buildings reflect the changes in our town. It is hoped that this book reflects those changes in a positive light, whether simply through nostalgia or an acknowledgement that change is inevitable.

The 50 Buildings

1. Church of St Mary

The flint and stone Church of St Mary is the oldest building in Watford and is the town's central parish church. Unfortunately, the date of the first church on this site is unknown, but no part of the existing church building dates from earlier than approximately 1230. The parts of the thirteenth-century structure in the Early English style of architecture that still remain are the chancel, a doorway and the south arcade of the nave (pillars and arches). Most of the current building dates from the fifteenth century, though the exterior was extensively repaired in 1871. It was then that the flint facing was put on the outside walls, which remains such a distinctive feature of the church. The 1871 refurbishment was designed by the architect John Thomas Christopher. However, a plan for alterations from this period also exists by the nationally renowned architect Sir George Gilbert Scott, who was responsible for St Pancras station and, locally, All Saints Church on Horseshoe Lane. The interior was restored in 1848 and the church centre on the south side is a modern addition from 1979. The roof was once again restored in 1987. Some of the timbers were

An early image of St Mary's Church and churchyard.

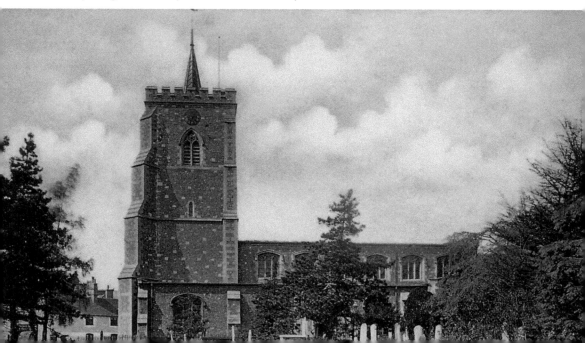

infected with death watch beetle and the parapet stonework in the tower had begun to crumble. Parts of the lead roof were replaced and steel pins inserted into some of the timber joints to prevent the roof sagging any further and the walls bowing outwards.

One of the most outstanding features of St Mary's Church is the north chancel chapel, known as the Essex or Morison Chapel. Here are found outstanding monuments to the earliest Earls of Essex from Cassiobury House including two wall monuments by Nicholas Stone. On one side of the chapel is the tomb of Sir Charles Morison, dating from 1598, and opposite is his son, also Sir Charles, dating from 1628. A wall monument to Lady Dorothy Morison is also present from *c.* 1618 along with memorials to later earls, including George Capell-Coningsby, the 5th Earl of Essex, and Arthur Algernon Capell, the 6th Earl of Essex. The chapel was originally founded in 1595 by Bridget, Dowager Countess of Bedford and the widow of Sir Richard Morison, and previously Francis Russell, the 2nd Earl of Bedford. In 1916, the chapel was restored by Adele, Dowager Countess of Essex, in memory of her husband, George Capell, the 7th Earl of Essex. Among one of the more notable past vicars of St Mary's was William Capel, son of the 3rd Earl of Essex and a notable amateur cricketer. Despite its central location and importance locally, it is remarkable how few people are aware of this architectural masterpiece and the incredible Essex chapel. Yet despite this, the church is still very much central to the life of Watford and its growing community.

St Mary's Church and churchyard, the oldest remaining building in Watford. The tombs in the churchyard were restored with the help of a Heritage Lottery Fund grant in 2012.

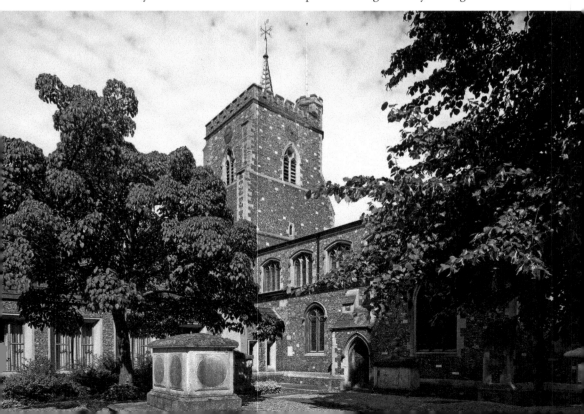

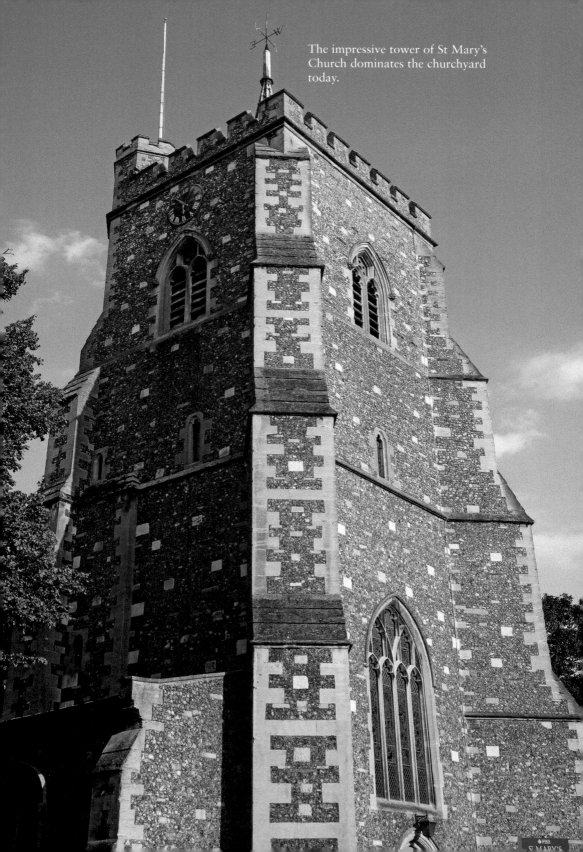

The impressive tower of St Mary's Church dominates the churchyard today.

2. Bedford and Essex Almshouses

The Bedford almshouses are among the oldest buildings to have survived in Watford, dating from 1580 and consisting of eight cottages. They were built by Francis Russell, 2nd Earl of Bedford, and his wife, Lady Bridget, to house eight poor women from Watford, Chenies and Langley. The Earl of Essex, Charles Morison, resident at Cassiobury House, also paid an annual sum towards their upkeep in the form of a 'yearly pension of £20 and sixteen loads of firewood for the inmates', and in 1629, Dame Mary Morison further endowed the almshouses with a yearly sum of £20 16s. In the early 1830s they were in a state of dilapidation and were in danger of demolition but by 1832 a report of the charity commissioners described them as 'The Almshouses are a lathe-and-plaster building containing 16 apartments on the ground-floor (being two for each Almswoman) together with a large common room on the upper floor. There is a garden behind the building, which is divided into eight portions. These are at their own option either cultivated by the women themselves or let at small rents by them for their own benefit.'

By 1930 there was a plan to demolish them to make way for a car park, but a public campaign led by Councillor Bickerton secured their survival and refurbishment. Reporting in 1930, Mr A. R. Powys, secretary of the Society for the Protection of Ancient Buildings, noted the buildings as being 'of considerable interest and beauty, being buildings of the late sixteenth century ... and form a beautiful portion of Watford, which would be harmed by their loss'. Today, their use is guaranteed and they are an important part of Watford's history.

The Bedford almshouses date from 1580.

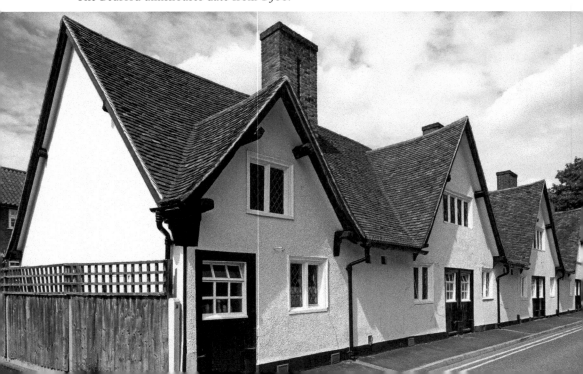

3. The One Crown

The One Crown is believed to be the oldest public house in Watford and is an example of a timber-framed house that has been re-fronted, with the original dating from the sixteenth century and refronted in the nineteenth century. Original features such as the ceiling beams remain intact and are integral to the buildings structure and character.

The pub was originally an inn that could provide accommodation for two guests, and was established in order to cater for the local and passing coach trade. The earliest legal record of the pub dates back to the 1750s, when the landlord at the time, Jeremiah Friend, obtained the pub's first full licence. Over the years, the pub has changed hands on a number of occasions, and has been owned by significant figures in Watford's history including renowned local brewer Edmund Fearnley-Whittingstall, who was associated with local brewery Sedgwick's. Sedgwick's is thought to have its origins in a brewhouse owned by William Smith and was located in Watford High Street around 1655. Continuing under family ownership, William Smith's brewery underwent modest expansion until 1790 when it was sold to George Whittingstall. It was George who instigated more significant expansion of the brewery and tied estate until he died in 1822 when he left the brewery to a cousin, Edmund Fearnley, on condition that he change his name to Edmund Fearnley-Whittingstall.

The One Crown remains one of Watford's most popular public houses and the oldest remaining one in the town.

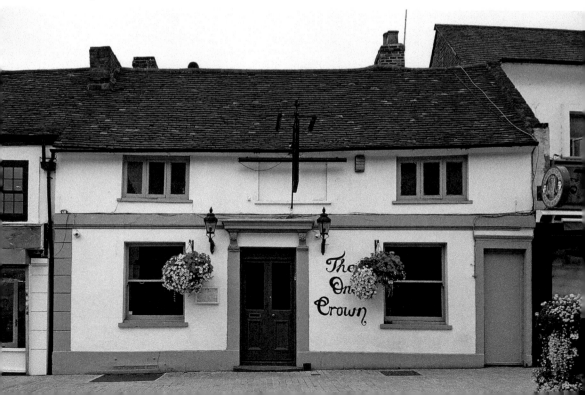

Expansion was to continue. Sadly though, upon Edmund's death the brewery estate become liable for debts arising from his other business ventures, and so the decision was made to lease the brewery and tied estate to William F. Sedgwick starting from 1862. The brewery remained in the Sedgwick family, and they expanded by purchasing the Colne Brewery, Uxbridge, in 1896, Wild's Brewery, Rickmansworth in 1900, and Speedy's Brewery, Clapham, in 1923. However, later that year the brewery and tied estate was eventually sold to Benskin's Brewery for £597,000. The One Crown was refurbished in 2018, has retained many of its original features and is one of the few remaining public houses on the High Street.

4. Jackson the Jewellers

A quaint building sat on The Parade and at times almost unnoticeable is Jackson the Jewellers. It is the oldest surviving domestic building in Watford, and predates both the Bedford almshouses and The One Crown, dating back to at least 1500. Described in its listing as a timber-framed house with three bays and one bay over a carriage entrance, probably from the late sixteenth century, it provides an interesting example of the extent of the town in the late medieval period. It has been used as a shop since at least the nineteenth century and possibly even earlier. Jackson the Jewellers have been in Watford since it was founded in 1876, are the oldest family business in Watford and still trade today.

Jackson the Jeweller on The Parade, the oldest surviving domestic building in Watford.

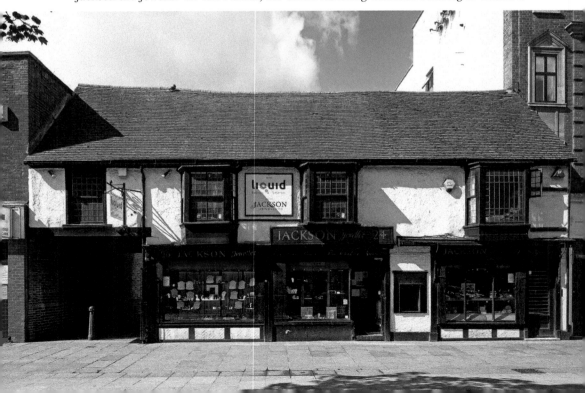

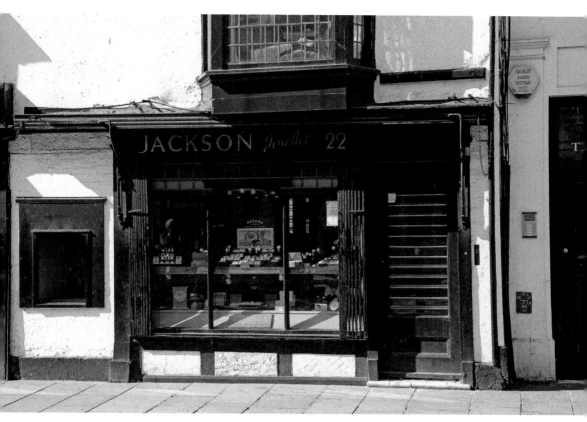

A quaint façade passed by many shoppers for centuries.

5. Monmouth House

Sir Robert Carey, who in 1603 took the news of Queen Elizabeth's death to James I, was created Earl of Monmouth and came to reside at nearby Moor Park, Rickmansworth. The earl built the house, which is referred to in the deeds as 'His Mansion House', and when he died in 1639, his widow occupied it as the dower house until her death in 1640. The grounds originally joined up with those of nearby Watford House and extended beyond the present railway line. The house was divided into two in 1771 and altered in 1830. The south house was named The Platts after the ancestral home in Worcestershire of the Cox family, who occupied the whole for centuries, and the north house was called Monmouth House. The northern half was entirely rebuilt in 1927 by local architect Henry Colbeck, who lived at Cheslyn House (see building 42) to match the southern half, which was heavily restored. The rebuilt parts used bricks from the demolished Cassiobury House. The entire building was eventually converted into shops and offices and remains so today.

Monmouth House on The Parade, a former dower house for the Earl of Monmouth.

6. The Dower Houses – Russells and Little Cassiobury

What was once known as Russell Farm also remains as a reminder of what Cassiobury once was. It was one of two dower houses, and at the time of their marriage in 1754, the Dowager Lady Essex moved into the dower house at Russell Farm. In 1837, Britton refers to 'The lodge to the seat called Russell Farm has recently been erected on the roadside between Watford and Berkhamsted with the seat being occupied by General Sir Charles Colville, Bart.' Other owners of Russell Farm have included William Copeland, a former Lord Mayor of London and the owner of Spode China, as well as the Maharaja of Baroda, who reputedly planted many interesting trees in the area. With alterations in the nineteenth century, its rather grand central stone Tuscan pedimented doorcase forms a fine entrance to the building. The house was let for many years before it was bought after the Second Word War by Hertfordshire County Council, who used it as a residential home for the elderly. When Hertfordshire County Council no longer required it, it remained empty for many years before being bought by a developer, who converted the house into flats and built houses in its grounds.

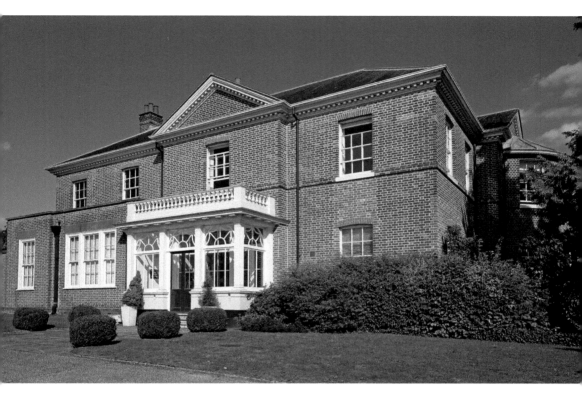

Russells, one of two former dower houses linked to the lost Cassiobury estate, now converted into flats.

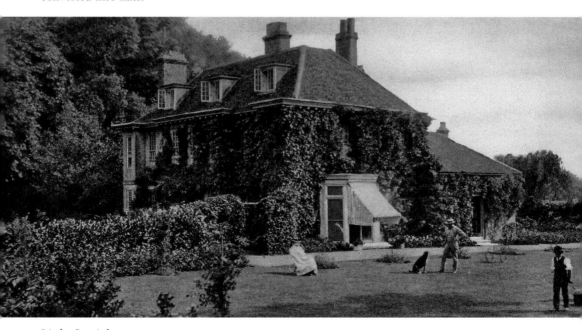

Little Cassiobury.

Cassiobury was the historic seat of the Earls of Essex, the Capel family, who lived in Cassiobury House, which was sadly demolished in 1927. Little Cassiobury is thought to be the dower house built for Elizabeth Percy, who became Countess of Essex, to live in from 1698 when the 2nd Earl of Essex, Algernon Capel, married and moved into Cassiobury House with his new wife. The exact date of Little Cassiobury's construction is still unknown, although a recent study suggests the house could have been built in the late seventeenth century, around the same time as architect Hugh May, who was working on Cassiobury House.

The countess lived for thirty-four years as a widow to the age of eighty-two, dying in 1717 or 1718 and having outlived her son by seven years. The dower house was built in a modest Queen Anne style and is certainly in keeping with the style and scale of a dower house. Following the death of Elizabeth Capel, historical records suggest that Little Cassiobury remained in use by the Earl of Essex's family until it was leased out to a church organist in 1770.

Members of the Capel family were known to have occupied the house again during the 1840s to the 1890s, with the exception of medical commander George Woodhouse, who was resident in the 1850s, and Irish landowner Joseph Gough, who was at Little Cassiobury at the time of the 1861 census. In 1899, the house was leased to a merchant from Siam returning from a twenty-year stint in Bangkok. After this date, although Little Cassiobury remained in the Earl of Essex's family ownership until 1922, the Capel family never again occupied the house.

Between 1929 and 1939, the Cassiobury estate was sold by Adele, Countess Dowager of Essex, and Little Cassiobury was enlarged after being bought by George Blake in 1922. Blake was an import and export merchant who sat on one of Watford Borough Council's planning sub-committees and acquired lots two and three and engaged renowned architect Clough Williams-Ellis to propose a plan for the development of his new estate. The two-storey extension at the rear of the property is Williams-Ellis's work. By the 1930s Little Cassiobury was home to the family of chartered accountant Henry Lancelot. H. Hill engaged Clough William-Ellis to improve the house internally. They were the last people to call Little Cassiobury their home.

In 1939 Hertfordshire County Council acquired Little Cassiobury by compulsory purchase and this fine residence was converted into offices as the surrounding area filled up with houses, schools and colleges. From the 1950s Little Cassiobury formed part of Watford Technical College, now West Herts College. Plans were drawn up in 1961 to add an L-shaped extension to the north elevation of the former stable block. These plans were revised in 1966 and the Ordnance Survey map published in 1975 shows that the extension had been carried out to convert the building for use as offices. Little Cassiobury was described by Pevsner in 1977 as 'the best classical house in Watford'. Having now being unoccupied and in a poor state of repair for several years, its declining condition has left it uninhabitable and has also led to the building being put on Historic England's Heritage at Risk register.

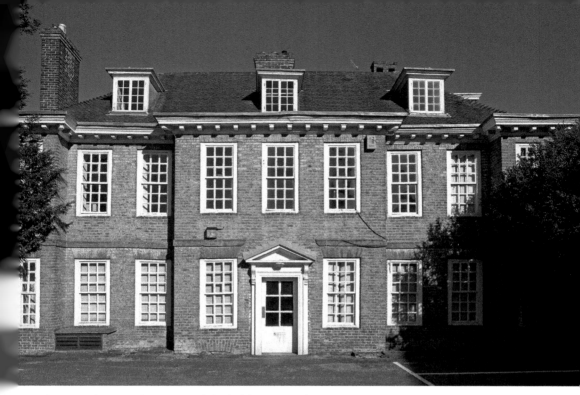

Above: Little Cassiobury, one of the hidden gems of Watford, also a former dower house to the Earls of Essex.

Below: Little Cassiobury extension by architect Clough Williams-Ellis.

7. Mrs Elizabeth Fuller Free School

One of the most loved buildings in Watford today is the Free School, which dates back to 1704. The foundress of the Watford Free School belonged to the family of Chilcott and was born in 1644 in Tiverton, Devon. Mrs Elizebeth Fuller came from a family who were noted for their generosity, with the town of Tiverton also possessing a Free School founded by the Chilcotts.

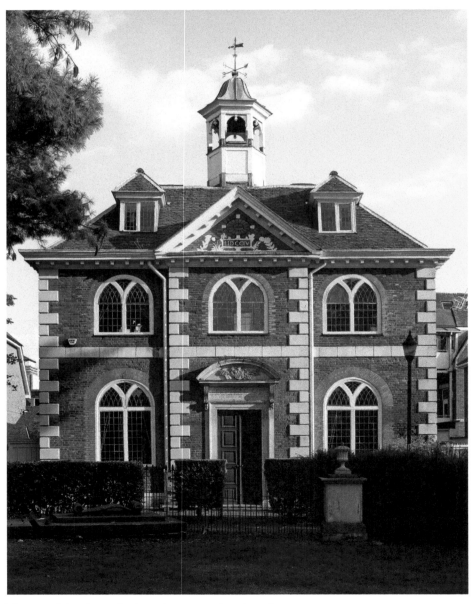

The Free School, overlooking St Mary's churchyard.

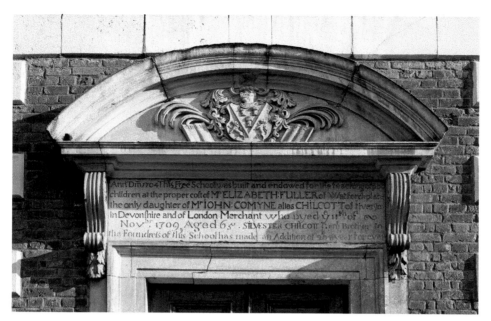

The inscription over the main entrance to the former Free School.

Mrs Fuller was three times a widow and at her third widowhood she decided to devote her life to charity and her principal care was to be the Watford Free School, which she is said to have visited daily in order to hear the boys and girls read the scriptures. It was from 1706 up until her death in 1709 that Mrs Fuller personally directed affairs of the school, but by a deed of gift dated 5 March 1708, she granted to trustees the building and an endowment of £52 'for the teaching of forty poor boys and fourteen poor girls of Watford in good literature and manners'. The pupils had to attend school every morning from six from Candlemas to Allhallowstide and seven in the morning for the rest of the year. It was required that the children were not to 'be absent, nor behave themselves irreverently nor to be given to ... incivility towards their betters, disobedience or the like'. There was certainly little time for rest for teachers or pupils with Saturday certainly no day off and Sundays being spent in 'catechising the children in the Church Catechism'.

In 1753, the school was beginning to struggle with funding with the original endowment increased to £250 per annum by its last year of existence. With the establishment of elementary education in 1870, charity schools all over the country such as here ceased to function and the Watford Free School closed on 10 August 1882. It was handed to the vicar and trustees and used for parish purposes. A new school was opened in Derby Road called the Endowed School and was opened in April 1884, with the trustees of the Old Free School becoming governors here. Again, accommodation was deemed inadequate and the Girls' Grammar School was erected in 1907 and the Boys' Grammar School in 1912. The school in Derby Road eventually became Central School.

Today, the building is a wonderful example of the architecture of the Queen Anne period and has undergone a number of restorations. The inscription over the entrance to the building reads 'Anno Domini 1704. This Free School was built and endowed for the teaching of poor children at the proper cost of Mrs. Elizabeth Fuller of Watford Place...' Used by the adjacent St Mary's Church as a church hall, it was eventually sold and converted into offices.

8. Frogmore House

Frogmore House is a rare architectural survival and dates from 1716. It was built for Isaac Finch (the Elder), who was a wealthy local merchant specializing in the leather dressing trade. Locally he was also known as a 'tanner' and a 'leatherseller'. He died in 1732 and his death was reported in *The Gentleman's Magazine* as 'Mr Isaac Finch of Watford in Hertfordshire has died at the age of 104. He followed the trade of a leatherseller for 80 years and at his death was worth £15,000'. His house, built of red brick and three storeys high, was intended as the family home but was something of a status symbol of the rising success of the Finch family business located in part of the estate on the River Colne to the south end of the town. The house was surrounded by an 18-acre estate and subsequently descended through the Finch-Shipton family and by 1775 onwards the grounds extended as far down to the River Colne itself. It was eventually rented to a number of successive tenants including London stage actor John Horatio Savigny, who used it like a villa riverside retreat as well as to a prominent surgeon called James Birch Sharpe, who was living there in 1824 as a tenant to Elizabeth Ward Linhouse. After she died in 1835, the Frogmore estate was sold to Phillip Cowley, from whom Mary Ann Hill, his daughter, inherited it in 1854. The house was once again leased to a number of tenants with the house consisting of a library, outbuildings, two summerhouses and a coach house and stable. Within the extensive gardens was also a dovecote.

By 1904 the entire property was sold to the Watford Gas and Coke Company and became part of a large gasworks site. In 1910, the High Street was widened and a large gas container was built adjacent to the walled garden, with the house initially used as a warden's residence. By 1946, it had been converted to three flats for employees of the gas company, and the adjacent Frogmore Cottages were constructed to the designs of Dawe & Carter.

Its historic importance was first recognised and it was listed in 1952 but continued to serve as a residence for gas company employees until the 1980s when the British Gas Corporation became British Gas PLC. Soon after the building became empty and unoccupied and went into serious decline. Unsympathetic repairs were carried out including the loss of features such as the large ornamental doorcase from the High Street elevation and the original hopperhead with the date '1716'.

In 2009, The Temple Trust identified the building on the English Heritage Buildings at Risk register and has since been developing proposals to see the building restored – as yet without success. It remains on the current Historic England's national Heritage at Risk register with proposals in the pipeline to see it restored as part of a wider development scheme.

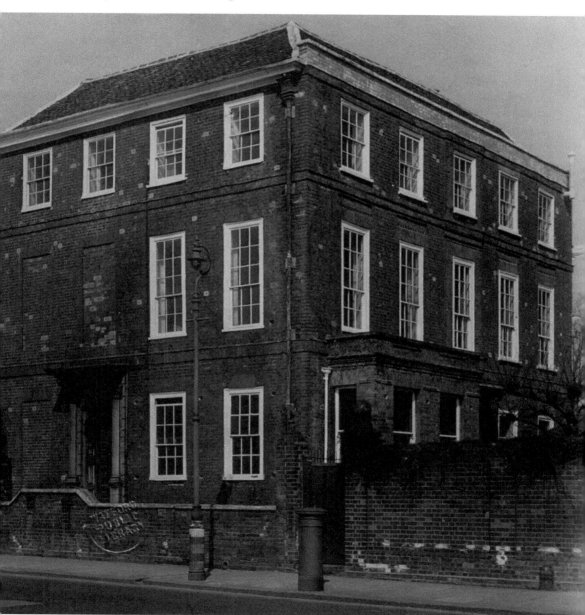

Frogmore House in 1947. (Courtesy of Watford Museum)

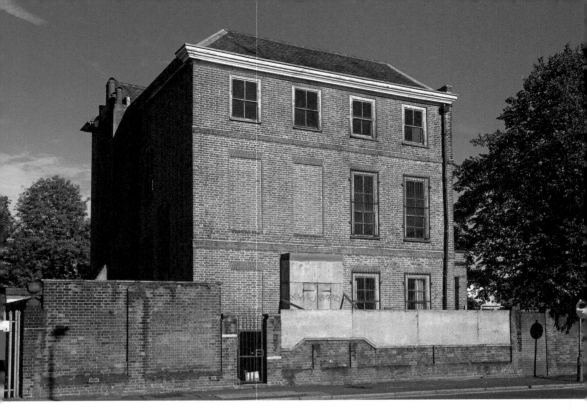

Frogmore House, currently sitting empty and virtually derelict. Intentions remain to see the building restored.

9. Watford Museum

In the seventeenth century, London brewers began to leave the side of the Thames, from which they drew water for the manufacture of malt liquors, and set up in the suburbs and smaller towns on the outskirts of the capital. Watford is said to have been the first place selected for the establishment of a public brewery, and Messrs Sedgwick could trace their property back to 1655, while Messrs Benskin have deeds showing that Cannon Brewery in the High Street was in existence in 1750. Benskins eventually absorbed Sedgwick's in 1924.

When this fine house was built in 1775 it was originally the home of Edmund Dawson. Later, it passed to brewer John Dyson and then eventually to Joseph Benskin. At first the Benskin family lived here but in time the house became the company's head office and it continued to be brewery offices until the entire site was bought by Watford Council in 1975. The house now accommodates Watford Museum, which opened in 1981.

Benskin's have long been associated with Watford and have had its roots in the brewery founded in Watford by John Pope, a local miller and baker around 1693. The brewery was inherited by his second son, Daniel Pope, in 1722, and passed to Daniel's sister Sarah Pope and her husband William Dyson in 1741 at his death.

For the next three generations part of the brewery was inherited by a John Dyson (son, grandson and great-grandson of Sarah Pope and William Dyson), each of whom bought out his co-heirs. When the third John Dyson died in 1867 the brewery was sold at auction to retired London hotelier Joseph Benskin and Watford draper William Bradley for £34,000. Bradley soon left the partnership, and in 1870 Benskin continued alone.

Benskin's rose to become the only regional brewer Hertfordshire ever produced, and during its life its estate included pubs, beerhouses and off-licences not only in its home county, but as far afield as Sussex, Essex, Suffolk, Cambridgeshire, Bedfordshire, Buckinghamshire, Kent and Greater London. The brewery was to remain a family business until a takeover bid was accepted from Ind Coope in 1957. At the time of the sale to Ind Coope, the Benskin's estate numbered 636 pubs and hotels and sixteen off-licences. The Benskin's name was retained for a number of years after the sale, and brewing continued at Watford until 1972. Ownership of the current Benskin's trademarks currently rests with Carlsberg breweries.

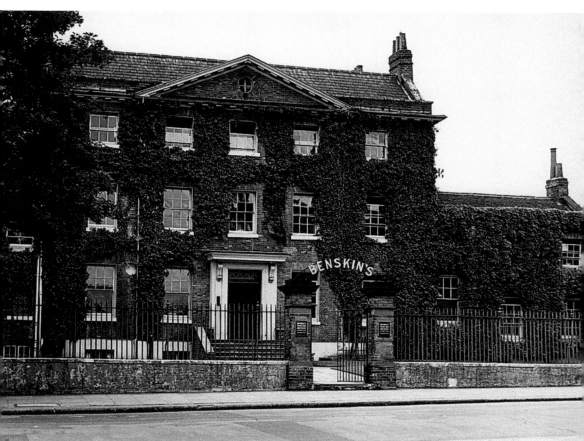

Benskin's Brewery and the company's former head office.

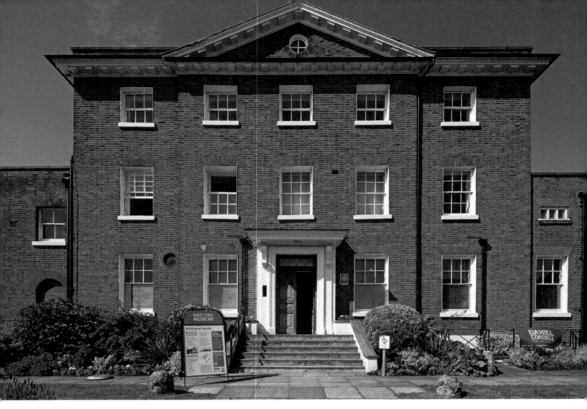

Purchased by Watford Borough Council in 1975, it is now the home of Watford Museum, which opened in 1981.

1c. Shrodells and Union Workhouse

The Union workhouse was built in 1838 following the Poor Law Amendment Act of 1834 to replace Watford's old parish workhouse, which used to stand opposite the parish church in Church Street. 'Union' refers to the grouping of parishes who supported the workhouse and whose paupers could be accommodated there. The architect for the building was T. L. Evans. Its original appearance was rather uninviting and harsh with a 'prison-like' appearance. The building itself used to provide the basic needs of the poor of the district where they could obtain one decent meal a day and a bed for a night. However, in return, adults and young children were hired out to households and local factory owners and were required to carry out a wide variety of menial tasks, usually for very long and difficult hours. It was renamed Shrodells in the 1930s, when the Board of Guardians was replaced by the Watford Guardians Committee. The name 'Shrodells' means 'shrubberies' and was taken from a list of Watford gardens in an old tithe block. It eventually became a geriatric hospital when the National Health Service was established in 1948. With the development of Watford General Hospital on this site, to replace the Peace Memorial Hospital, this central block came to be used as offices and an administration building for the main hospital.

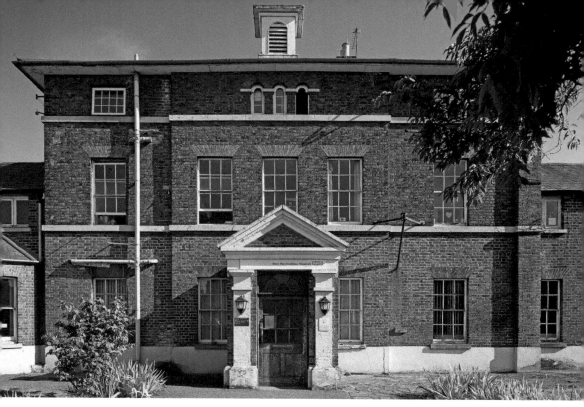

Shrodells, the former Union workhouse, now an administration building for Watford General Hospital.

The whole outlook of the building changed when a low front range was demolished in 1950, leaving an open courtyard plan. Today, its future is uncertain as the hospital evolves with modernisation in the pipeline. It forms an impressive frontage to a mixed and confused architectural variety of styles of the current hospital.

11. Cassiobury Estate Lodges

Cassiobridge Lodge, No. 67 Gade Avenue

There has often been confusion over the identity of many of the lodges and cottages to the once great Cassiobury estate, due to the fact that in many cases a lodge may have been known by two or three different names. One of the most unusual lodges is at the southern tip of Cassiobury Park and is the Grade II listed Cassiobridge Lodge. It was described by Britton in 1837 as 'the most elaborate in execution; its whole exterior being covered, or cased with pieces of sticks of various sizes split in two'. It is built in a picturesque style with the original ornamental timber cladding and a prominent ornamented brick chimney stack, and it is from here that a path leads north alongside the east bank of the River Gade into Cassiobury Park. It certainly originated from the early nineteenth century and is characterised by a plain tiled roof that has a rather grand central brick and stone chimney with a cluster of four stacks. The lodge was built originally for two families.

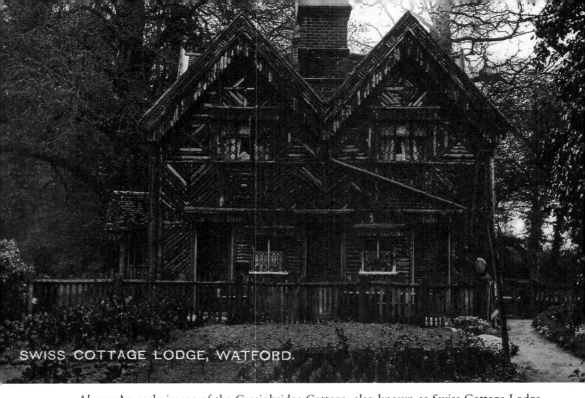

SWISS COTTAGE LODGE, WATFORD.

Above: An early image of the Cassiobridge Cottage, also known as Swiss Cottage Lodge according to this postcard.

Below: Cassiobridge Lodge is still lived in to this day.

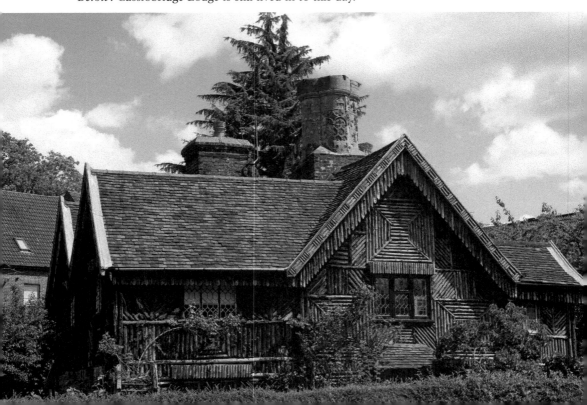

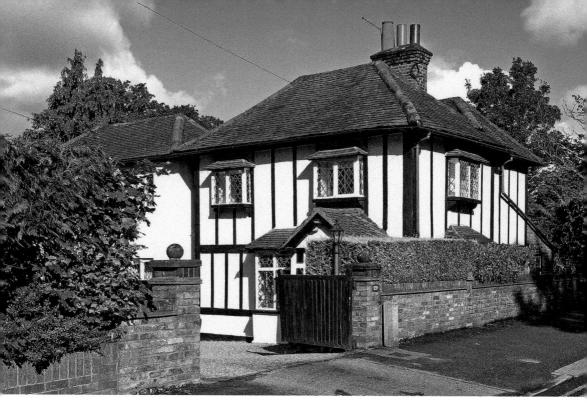

Garden Cottage on Hempstead Road.

Garden Cottage, Hempstead Road

The Grade II listed Garden Lodge is also an early nineteenth-century half-timbered former lodge to Cassiobury House. Built as a two-storey cottage with a hipped valley roof, plain tiles and central brick chimney in the valley, this and No. 235 Hempstead Road are some of the only lodges to have survived on the Hempstead Road boundary of the Earl of Essex family's Cassiobury House. As it is not included in Britton's account of Cassiobury, as are other lodges, it may have been built shortly after that book was published in 1837.

Toll Gate Lodge, Hempstead Road

The former drive from Cassiobury House extended north across the park to join a network of drives leading to the former Cassiobury House. This Grade II listed and early nineteenth-century picturesque half-timber and brick cottage is the former Ridge Lane Lodge to Cassiobury estate and is also illustrated in Britton's account of Cassiobury of 1837. It was often known as Toll Gate Cottage but was never actually a toll house. Tolls were collected by the Sparrow's Turnpike Trust between 1762 and 1872, at a gate on Hempstead Road, near Ridge Lane. It was originally built for two families and divided horizontally with an external stair.

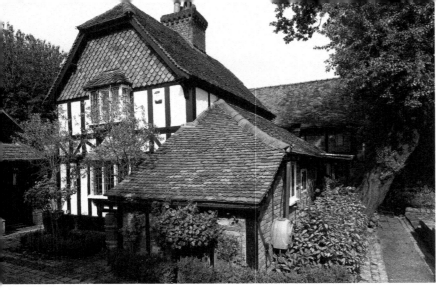

Toll Gate
Lodge opposite
Ridge Lane.

Home Farm Lodge, Hempstead Road

The locally listed Home Farm Lodge (No. 191 Hempstead Road) was also constructed in 1872 as a lodge to the Cassiobury estate. It was located on the western side of the Hempstead Road, and the lodge marked the junction with a track heading west towards Home Farm, which was a principal group of agricultural buildings on the Cassiobury estate.

Home Farm Lodge on Hempstead Road, at the former entrance to the former Cassiobury estate.

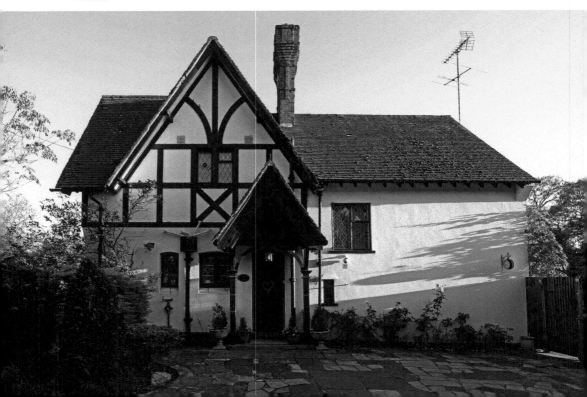

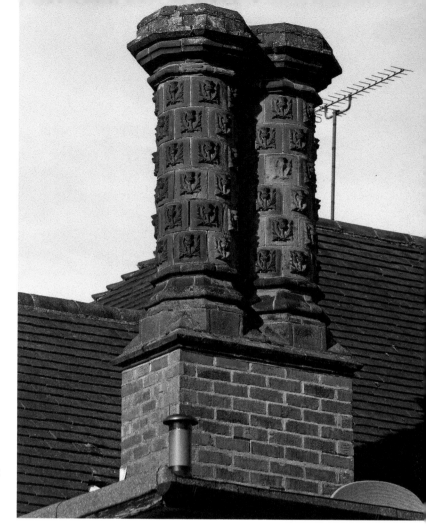

One of the many chimneys that remain from the former Cassiobury House that adorn a number of properties across the Cassiobury estate.

12. Cassiobury Court

Dating from between 1805 and 1815, Cassiobury Court is the former stables and is the most substantial surviving vestige of the estate buildings relating to Cassiobury House. As an outbuilding, it survived the demolition of the main house in 1927 and has had varied uses over the years, including as a riding school in the 1930s. In 1951, it was partly rebuilt as an old people's home; however, it has since come into alternative use. Technical analysis in 2010 suggested that the historic core has much earlier origins than its national listing description would suggest, with brickwork and a roof structure indicative of an early eighteenth-century date. This period is poorly documented, but the work is of the highest quality and possibly by a notable architect. The building was later extended and modified in the Gothic style by James Wyatt from 1799, when the mansion was remodelled and other estate buildings were constructed in a similar style.

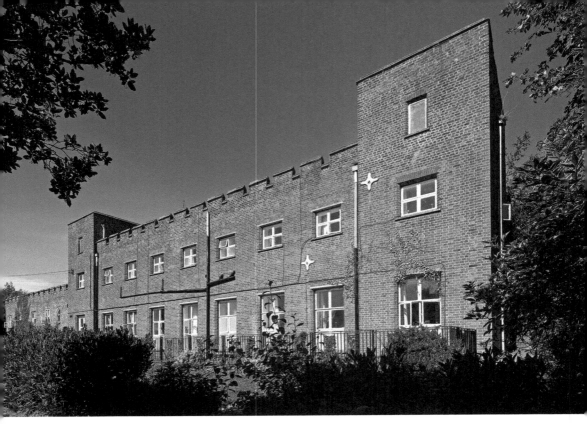

Cassiobury Court, the former stables to Cassiobury House.

13. Church of St Andrew

One of the finest churches in Watford, the Church of St Andrew was built to serve
the needs of the increasing numbers of people who came to live in this part of
Watford from the 1840s onwards and especially as a result of the opening of the
London & Birmingham Railway in 1837. The influx of people into the growing
area of Nascot meant that a new church was required as a place of worship as
St Mary's was the only other place available for worship. It was built on land
that had been part of the Earl of Essex's Cassiobury estate, and was commenced
in 1853 when the foundation stone was laid and ultimately consecrated in 1857.
It was designed in a decorated Gothic style using flint and stone. The principal
architect of the church was Samuel Sanders Teulon (1812–73), who was born in
Greenwich and later lived and had his architectural practice in London. He was to
become well-known in his own right and during his long career was responsible
for the design of 114 new or restored churches. St Andrew's is certainly one of his
finest achievements. The later addition of the south aisle in 1865 was, however,
the work of the architect W. W. Baldwin. One of the more unusual features of the
church is the incorporation of seven old stone railway sleepers into the building in
recognition of the building's close relationship with the railway industry.

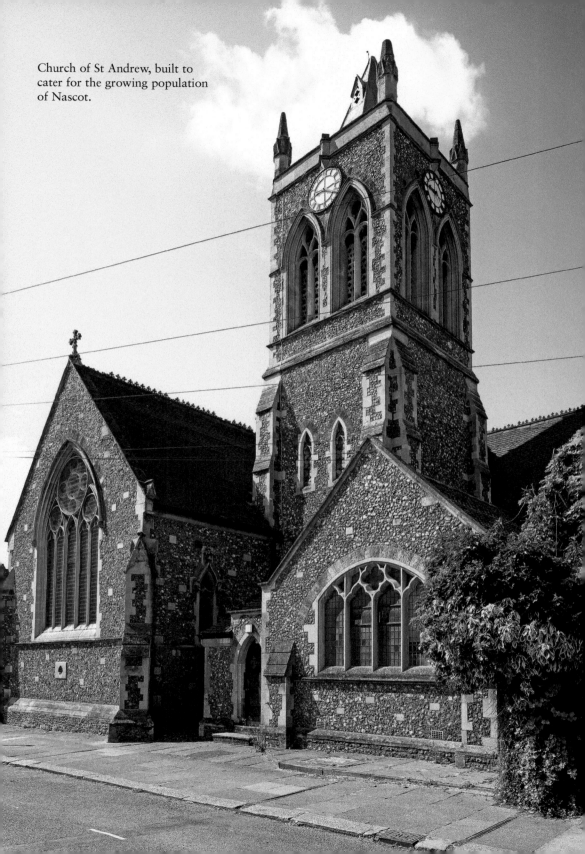

Church of St Andrew, built to cater for the growing population of Nascot.

14. Kytes Place

Tucked away in Meriden is Kytes Place, an early nineteenth-century brown-brick house. It was used by the army in the Second World War, and the house was bought by a trust afterwards using funds raised by the Order of St John of Jerusalem and the British Red Cross Society. Bungalows for disabled people were built in the grounds in 1949 immediately adjacent to the house, which was retained for use by the Trust. The rest of the estate was sold for housing and was developed in the 1950s. This area was occupied originally by farmland until the early nineteenth century, when Kytes House was constructed, along with various estate buildings, such as stables. A lodge followed to the west in the late nineteenth century and two additional houses were built to the north in the early twentieth century. Within Watford, the house is now surrounded by very low density housing development, with an informal street layout dominated by the parkland setting of Kytes House, which is unlike many of the more recent housing developments in the town.

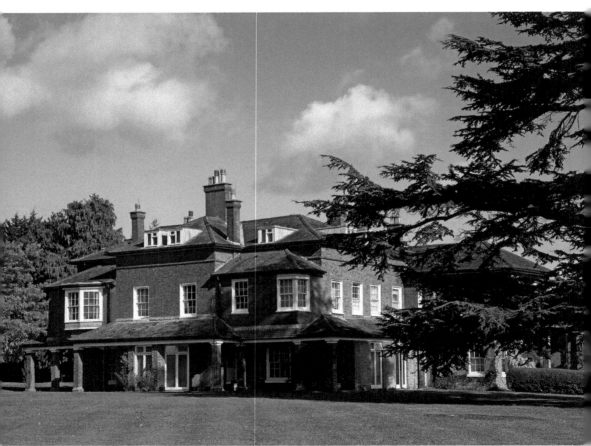

Kytes Place, built in the nineteenth century.

15. Church of All Saints

All Saints Church was designed by the architect Sir George Gilbert Scott (1811–78), who was one of the most important architects and designers of the nineteenth century and had a career that was marked by a series of highly prestigious achievements. Scott was born in Gawcott in Buckinghamshire, but lived and worked for most of his life in London and was involved in projects throughout the country and beyond. He was for many years professor of architecture at the Royal Academy and was president of the Royal Institute of British Architects between 1873 and 1876. Some of his most notable projects include the designs for Glasgow University, the Foreign & Colonial Offices in London and the stunning building of St Pancras station. He was knighted for services to architecture in 1872. He was the most prolific architect of his age, and possibly of all time, and also the most unsung. His works spanned the empire, from New Zealand to Newfoundland. In England alone he designed 800 buildings and oversaw hundreds more restorations. He produced churches, schools, hospitals, workhouses, asylums and vicarages galore. He has 607 structures listed as historic, more than any other architect (next is Lutyens with 402), including the Albert Memorial, the Foreign Office, Edinburgh Cathedral and the universities of Glasgow and Bombay.

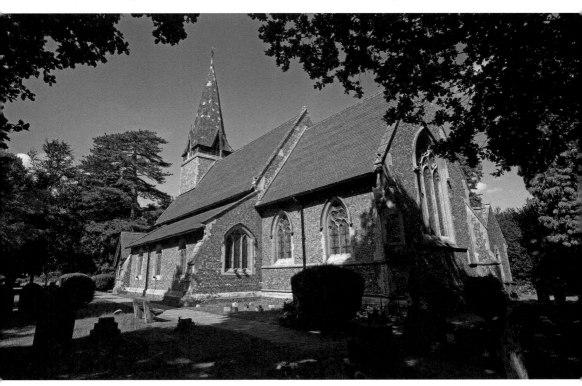

All Saints Church, designed by Sir George Gilbert Scott.

The fine steeple of All Saints Church.

Scott restored eighteen of the twenty-six English medieval cathedrals. From his office his grandson, Giles, designed Liverpool Cathedral, Battersea power station, red phone boxes and what is now Tate Modern. Scott towered over his profession, yet very little has been written about him.

It was during the Victorian era that All Saints was founded, being designed and built in 1853 by Scott. The church is of flint and has the appearance of simple Gothic design so that it is sometimes mistaken for being of a much greater age. It was the first church to be built in the area since the founding of St Mary's, Watford. A subscription scheme was begun, though the money did not always flow into the fund as quickly as had been hoped. The first vicar, Revd Adolphus White, was very much involved in the completion of the church even to the extent of paying for the glass in the east window while his brother provided the funds for the stone pulpit. Most of the stained glass was put in when the church was built and is thought to be the work of William Wailes of Newcastle.

16. Sikh Community Centre

An unusual building found in Lady's Close is the Sikh Community Centre but its history and previous use could not be more different. The building was Watford's first purpose-built courthouse. Previously, the local magistrates and judges had used various buildings including the Essex Arms, a local hotel where they met every Tuesday. The judges had their own entrance around the corner in what was then King Street, which had the royal coat of arms over the doorway. The list of Watford magistrates of 1871 and 1891 include many of the great and good locally, such as Lord Malden, Lt Col Foskett, the Earl of Essex and the Hon. R. Capel. Many of these were local landowners who dealt particularly harshly with poachers.

When the building was no longer required by the Lord Chancellor's department, it was converted by the Sikh community into a community centre. Built in a classical style around 1858, it consisted of offices, courtroom, cells, judge's chamber and a clerk's room at the back. The most impressive feature that remains is the stone cornice with the large royal arms in the centre. A new magistrates' court (see building 41) was opened on Clarendon Road in 1940, where it remains to this day.

The former courthouse, which is now a community centre.

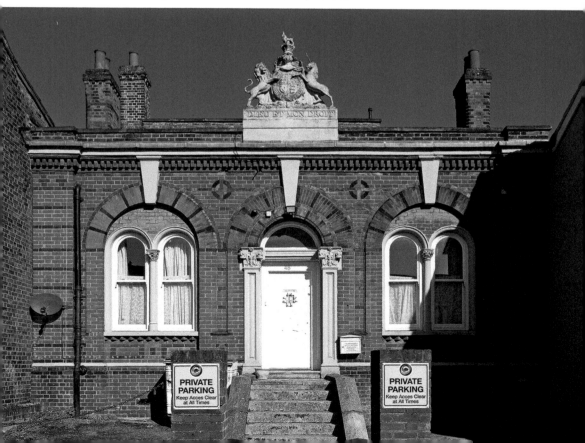

17. The Salter's Company Almshouses

Tucked away in the heart of Nascot are the Salter's Company almshouses on Church Road. They were built by one of the City of London livery companies, the Salters' Company, occasionally also known as the Drysalters. The almshouses were designed to house pensioners moved from the company's cramped city almshouses. Not all the buildings present today are part of the original building layout, with the site being extended first by the range of single-storey houses on the Church Road frontage. Later in 1992 a number of other almshouses were built in the gardens at the back. The original almshouses architect was Thomas Charles Sorby (1836–1924), who was born in Wakefield, Yorkshire, but worked primarily in London before eventually moving to Canada in 1883. While in London, he became the county court surveyor in 1867 and designed a number of high-profile buildings during the course of his career including Lambeth magistrates' court in 1869 in the Gothic Revival style.

Above: The Salter's Company almshouses built in 1863.

Below: The very Gothic-style Salter's Company almshouses.

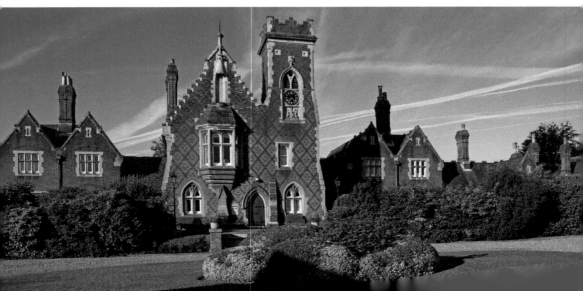

The Salter's almshouses date from 1863 and were built to house twelve females and eight males, and are also very much in a Gothic style and are certainly very picturesque in their landscaped grounds but also surround a fine courtyard. It's most prominent feature, however, is the crow-stepped gable and its asymmetrical tower, with its battlements, ornamental Gothic bell opening and clock.

18. The London Orphan Asylum

Designed by Henry Dawson in 1871, the former London Orphan Asylum is an extensive Gothic group of institutional buildings built for 500–600 orphans and 100 servants for £63,000. The London Orphan Asylum was one of several charitable bodies that moved in the nineteenth century from London to build in the cleaner air of Watford after a serious outbreak of typhus. The organisation was established in 1813 by the philanthropist Dr Andrew Reed 'to maintain, clothe and educate respectable children of either sex … whose fathers had lost their lives in the Army, Navy and Marine Services'. The site to build on was located by William Fellows Sedgwick and purchased in 1867 for £6,500. The building's foundation stone was laid on 15 July 1869 by the Prince of Wales and the buildings were officially opened by Princess Mary Adelaide of Teck on 20 July 1871. In 1915, it was given the new name of the London Orphan School and eventually renamed Reed's School in 1939. When the children were evacuated from here in 1940, the building was taken over by the then Ministry of Works and used as a hospital. After the war it was used as offices for many years by the Ministry of Labour until it was sold for housing in the 1980s, with work beginning on the site in 1989. Houses and flats were built in the grounds and finally the listed buildings were converted into flats.

The London Orphan School, dating from 1869.

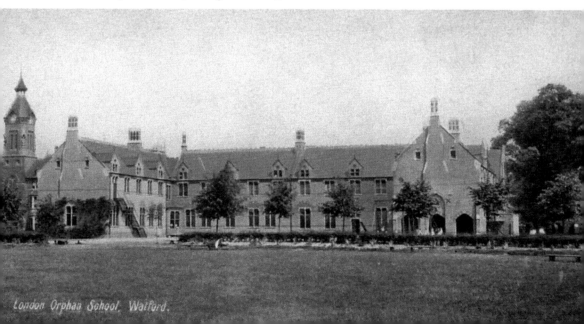

London Orphan School, Watford.

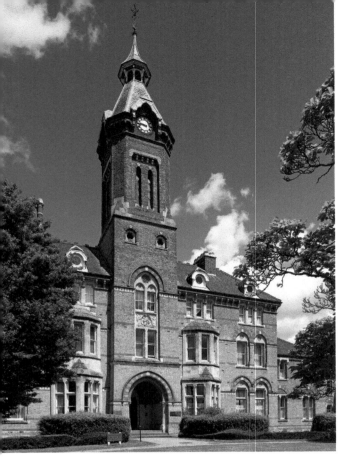

Left: The former London Orphan Asylum, now converted into flats.

Below: Within the grounds and one of the more prominent buildings is the polychrome brick Gothic chapel. It was built to serve the children of the asylum, but it was many years since it had been used as a chapel and was eventually converted to flats.

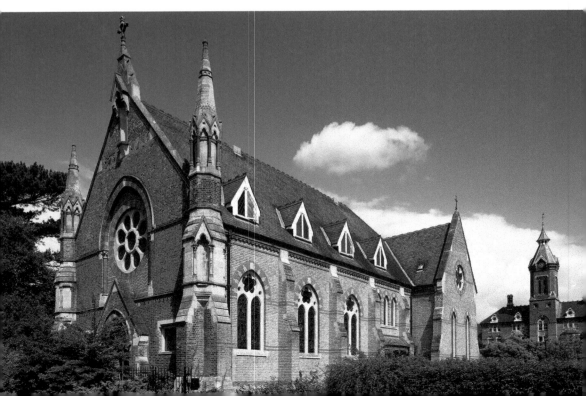

19. Beechen Grove Baptist Church

Baptists have worshipped in Watford since the early eighteenth century and there had been two previous meeting houses in Watford before the Beechen Grove Baptist Church was built. One of the previous places of worship was an earlier meeting house close to where Charter Place is located. It had been built for worship in 1721 after the beginning of Nonconformity in Watford several years earlier. The new Beechen Grove Baptist Church was designed by architect J. W. Chapman in 1877 in a late Romanesque style to seat 850 people and cost £9,000. It opened in 1878. On the previous site once stood the former Clarendon Hall and later a Territorial Drill Hall where many political meetings and gatherings were held, along with many lectures. Originally there was also a graveyard next to the church but the burials were moved to Vicarage Road Cemetery to make way for the development of the new ring road. In the 1970s, at one stage, there was even a shocking suggestion that the building might be demolished, but thankfully this came to nothing. Instead, during the 1980s part of the site was developed, with a floor inserted above the nave and other building refurbishments carried out.

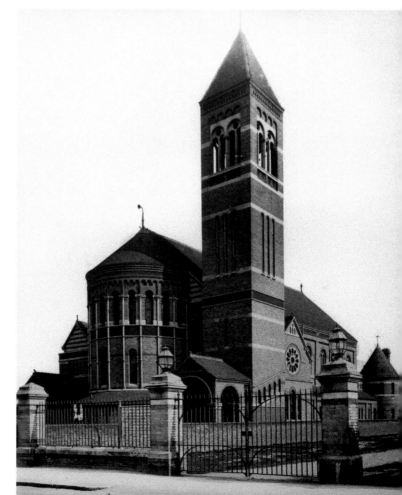

Beechen Grove Baptist
Church, dating from 1877.

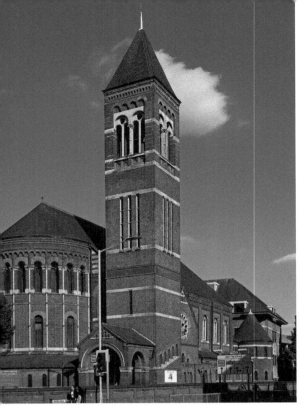

Above left: Beechen Grove Baptist Church, saved from demolition in the 1970s.

Above right: This church was designed by architect J. W. Chapman in 1877 in a late Romanesque style.

20. The Baptist Tabernacle

This is one of several Baptist chapels in Watford of which only this and Beechen Grove Baptist Chapel are nationally listed. Built in 1887, it was designed by architect William Henry Syme, who was born in Edinburgh but lived and worked in Watford for much of his life. He was a Fellow of the Royal Institute of British Architects from 1889, and designed a number of other notable buildings in Watford including St Mathew's Church in Oxhey, Bushey Baptist Church and a number of locally listed school buildings. Before coming to Watford, he was articled to Peddie & Kinnear from 1859 to 1864 and subsequently spent three years as improver in the office of David Bryce. While there he was honorary secretary of the Edinburgh Architectural Association in 1865–66. In 1867 he moved to London, where he assisted Benjamin Ferrey and Edward Cookworthy Robins until 1869. He spent the following nine years designing and superintending all the buildings on the estates of W. H. Smith MP, T. F. Halsey MP, Lord Chesham and others. He commenced independent practice in 1877 in Watford, where he remained in practice until at least 1914.

The Gothic-style Baptist Tabernacle was eventually opened on 4 January 1888 with its unusual and conical roofed turrets. It remains a thriving Baptist church today.

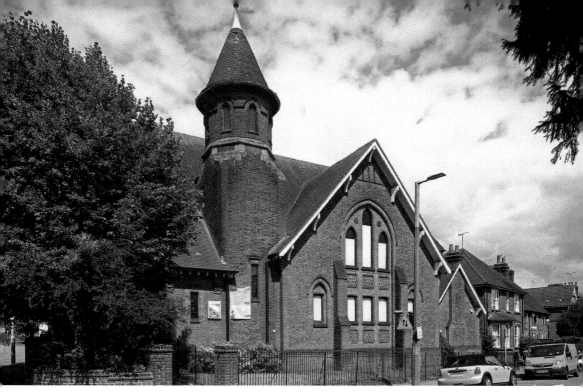

Above: The Baptist Tabernacle on Derby Road, built in the Gothic style.

Right: Derby Road Baptist Church and one of its fine conical turrets.

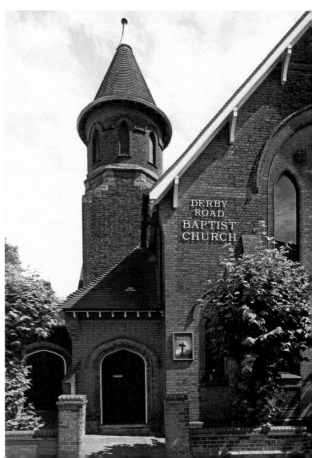

21. Nos 63–65 High Street

Originally built in 1889 for the Bucks and Oxon Bank to replace their first but rather modest branch, it eventually passed to Lloyds Bank when that company absorbed the Bucks and Oxon. It remained Lloyds' main High Street branch right up until the 1980s, when the bank developed the site next door and the old building was converted into a shop. It is a very unusual tall three-storey building, built in brick and terracotta with Gothic details, and provides a striking elevation in this part of the former marketplace in comparison to the rather bland former Lloyds Bank building, which existed next door. It has recently been restored and is now a popular restaurant.

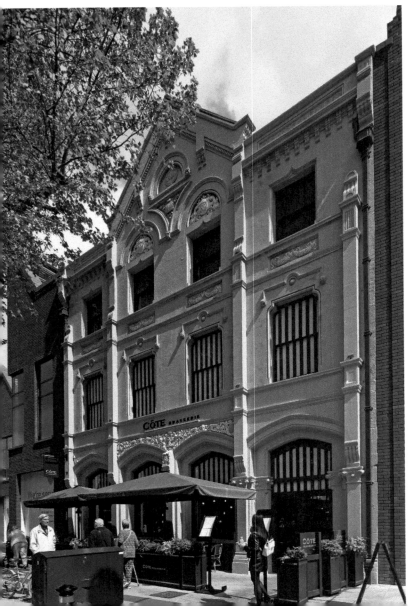

Nos 63–65 High Street, restored in 2019.

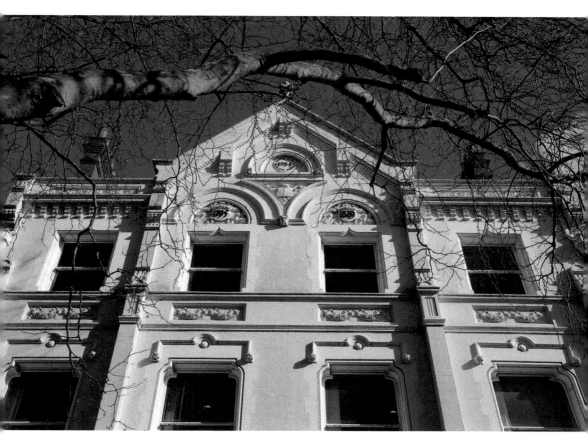

The terracotta detail of the former Lloyds Bank.

22. Holy Rood Church and House

Holy Rood Church is without exception one of the most loved and valuable buildings in Watford and is certainly worthy of its Grade I listing. In 1863 a Fr George Bampfield came to Watford to say Catholic mass in what was rented accommodation in Carey Place. The same year he bought some land and had a hut built there, which eventually became a chapel.

When Market Street was laid out in 1888, Stephen Taprell Holland, of Otterspool House, Aldenham, and owner of Holland & Sons, one of the largest and most successful cabinetmakers of the time, had bought a plot of land for a church and commissioned the renowned architect John Francis Bentley. Holland also paid for much of the building costs after becoming a Catholic himself while observing the devotion of one of his workers. The foundation stone was laid in 1889 and the first part of the building opened for worship in 1890. Building continued for some years and the completed church was consecrated in 1900. Extensive cleaning and redecoration was carried out in the 1990s.

The church is especially renowned because of the reputation of its architect, John Francis Bentley (1839–1902). Bentley was born in Doncaster but lived and worked for most of his life in London. As well as designing the adjacent Holy Rood House and former school building, Bentley was the architect for the highly prestigious commission of designing Westminster Abbey in London. In 1902 it was announced that Bentley was to receive the Royal Gold Medal – the highest possible honour bestowed by the Royal Institute of British Architects.

Today the church is an outstanding late Gothic Revival church constructed with flint and stone. Within the building is an elaborate and complete set of fittings by Bentley, which are unequalled elsewhere in his work, notably in chancel and east chapels, west baptistry and north aisle chantry chapel dedicated to Holland, the donor.

Originally tucked away at the side of Holy Rood Church, the presbytery now faces onto the busy Exchange Road and was also designed by Bentley. Built in 1890, it is noted for its rather grand moulded Gothic arched doorway.

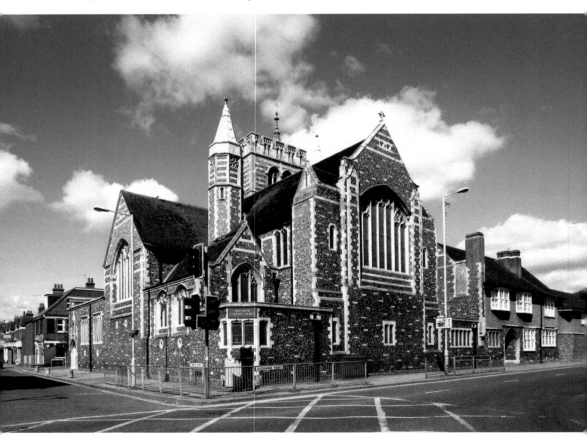

Watford is lucky to have many fine churches in the town and one of the grandest is Holy Rood.

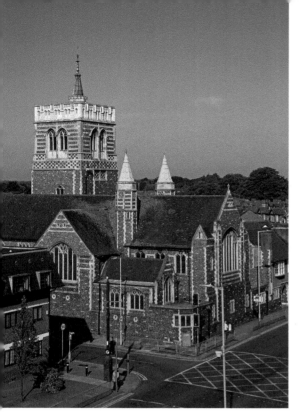
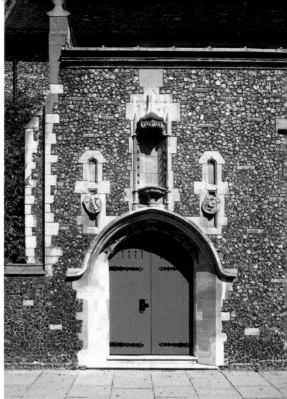

Above left: Holy Rood Church is especially renowned due to the architect John Francis Bentley.

Above right: Holy Rood Church, a late Gothic Revival church constructed with flint and stone.

23. Former Police Station

Before the founding of the Hertfordshire Constabulary in 1841, policing was simply based on the headborough and constable system, with officers elected by the manorial courts or by the vestry. The purpose was to keep order and include such local issues as 'suppression of drunkenness, popish recusants, and to deal with rogues and beggars whilst checking weights and measures'. A resident writing in 1883 recalls two watchmen who protected local people of the town from two guard boxes in the High Street, one near the pond and one at the other end of the street, calling the hours throughout the night. Ultimately, Watford's first purpose-built police station was opened on King Street in 1888 and it remained in use until 1940 before becoming the appropriately named Robert Peel public house. The building had eight cells, an exercise yard, offices and residential accommodation. By 1922, three inspectors, a superintendent, ten sergeants and sixty-seven constables were based there. Another former police station, the building at Nos 3–5 Estcourt Road, was built in the late nineteenth and was used

Above: Watford's first purpose-built police station on King Street.

Below: Henry Smith House has been a former police station as well as the office for the Inspector of Weights and Measures.

for checking weights and measures, which was at that time the responsibility of the police force. When it ceased to be one of their functions, the building subsequently became the local office of the 'Inspector of Weights & Measures, food & drugs, petroleum & explosives and fertilisers & feeding stuffs', which it remained until the late twentieth century. Now known as 'Henry Smith House', the building is the base for the Guideposts Trust, who use it for putting on activities for people with mental health problems.

24. Former Mill, Old Mill House and Cottage

On the periphery of town, on what appears to be a quiet country lane, is a cluster of buildings including a canal-side cottage and former mill, as well as the former Dower House from the Grove estate, all nestling alongside the Grand Union Canal. Previously called the Grand Junction Canal, it was built to improve the communications between Birmingham and the Midlands and London. It received its Act in 1793 and was fully opened in 1805, passing through Cassiobury Park in 1796 after permission was given by William Anne Holles Capel, the 4th Earl of Essex and the Earl of Clarendon. A commentator writing at the end of the eighteenth century wrote 'Cashioberry Park, is where we first fall in with the Grand Junction Canal. Ready permission was granted by the present Earl of Clarendon, and the late Earl of Essex, to allow this great national undertaking to pass through their respective parks ... it must stand as a monumental record, and example, of the urbanity and *amor practice*, these distinguished noblemen exhibited for the weal of their country.'

The former mill itself is over 3.5 storeys and is built in Old London stock bricks but has had a number of modern additions. It is an excellent example of a nineteenth-century mill building, which still provides the focus of the surrounding group of buildings. A mill has existed on this site for many centuries, using the flow of the River Gade that passes south at this point. The current building that occupies this site was constructed in 1875 and operated as a flour mill for the Grove estate until 1922. The miller and mill hands lived in the adjoining house and cottages. During the 1970s the building was converted into flats and a number of alterations were made. Various pieces of the former plant mechanism still remain adjacent to the western elevation of the building.

Opposite the former mill is a quaint and early nineteenth-century painted brick cottage. According to British Waterways records this building was built by the Grand Junction Canal Company around 1800 as accommodation for an employee whose job was to ensure the maintenance of an adequate water supply both to Grove Mill and the canal, and also to collect tolls from passing boat traffic. Together with the bridge over the Grand Union Canal, it forms a notable canal-side composition. The eastern, gabled part of the cottage was added later in the nineteenth century.

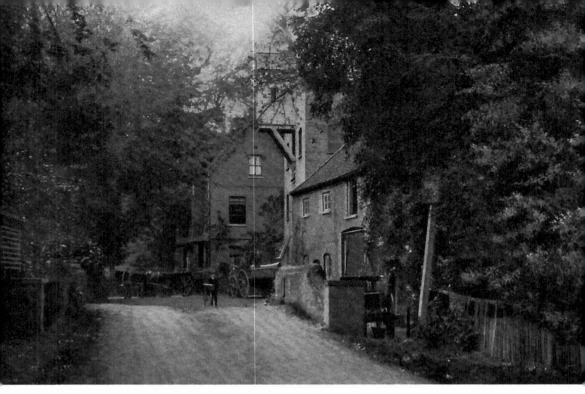

Above: Grove Mill Lane with cottages and mill.

Below: Not much has changed here on this rural lane.

Above: The small wooden structure on the side of the mill is a lucum, a sack hoist that lifted newly delivered bags of corn from a cart below and lowered the empty sacks by return to the estate.

Below: Old Mill House appears to date from the late nineteenth century and has three storeys. Along with the mill it was owned by British Rail (as part of their ownership of the Grove estate). For some time prior to 1947 it was used as offices and a restaurant. When the railways were nationalised in 1948 it was converted into two flats and used by employees of British Rail.

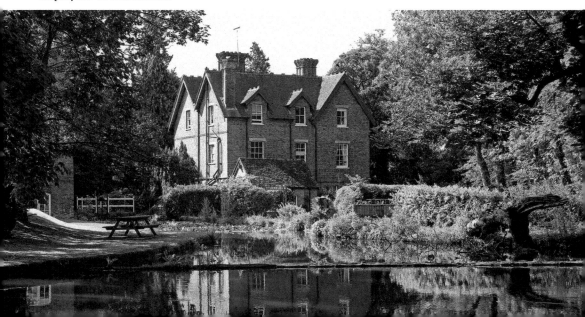

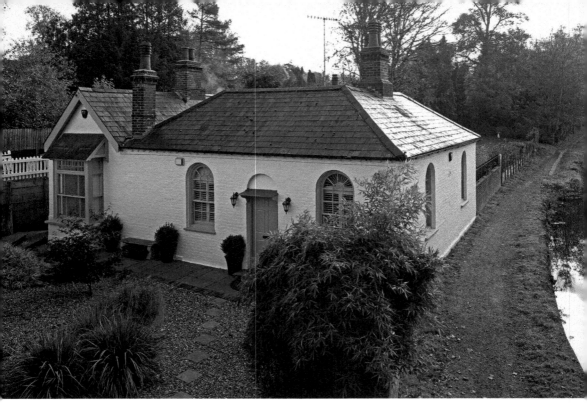

An early nineteenth-century painted brick cottage built by the Canal Company.

25. Victoria House, the former Cottage Hospital

Built at a cost of £17,000, the Victoria Cottage Hospital in Vicarage Road was opened by Lady Clarendon in 1886. The building itself is an excellent example of a Victorian cottage hospital, including fine detailing to its front elevation. It was designed by the local architect Charles Ayres, who was responsible for designing a number of other locally and nationally listed buildings in Watford.

It is thought to be Watford's first hospital, and was financed by public subscription. It was ultimately extended in 1897 to commemorate Queen Victoria's Diamond Jubilee with a six-bed ward and operating theatre, and again in 1902 to provide more space for further beds, but this time in memory of the coronation of Edward VII. After the First World War, and with Watford's increasing population, the hospital became inadequate and a larger building was required. It was eventually replaced as a general hospital by the opening of the Peace Memorial Hospital in 1925. Since then it has been used for a variety of medical uses such as a geriatric hospital and day centre. Today it is now used as offices.

The extensions at the east and west ends of the former building, which was built in similar style to the original, have memorial tablets to commemorate the opening of the former building by Lady Clarendon and later openings by Adeline, Duchess of Bedford. Other tablets commemorate the Diamond Jubilee and the coronation of the king in 1902.

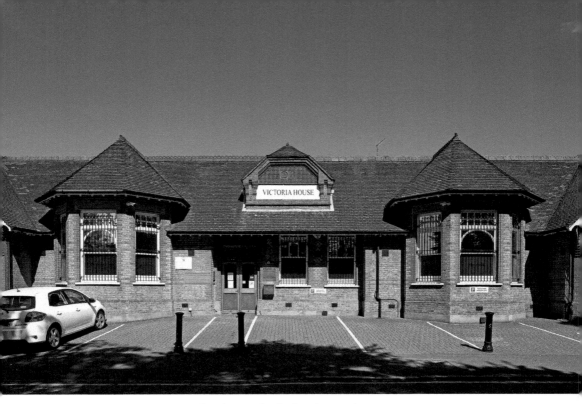

Above: Victoria House, reputed to be Watford's first hospital.

Below: One of the extensions to the former cottage hospital.

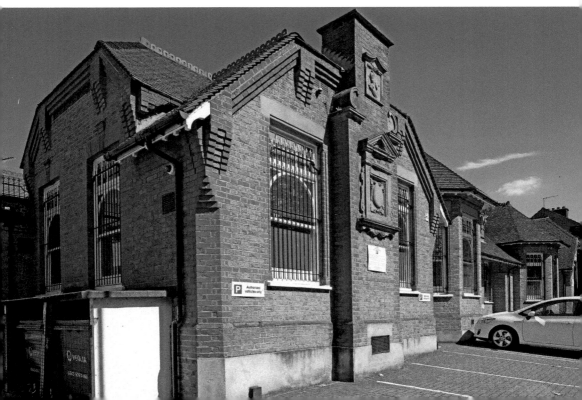

26. No. 73 High Street – HSBC Bank

One of the more unusual buildings on the High Street is a banking hall that faces onto the former marketplace and was built for the London, City and Midland Bank. It was eventually known as the Midland Bank but is now part of the Hong Kong and Shanghai Banking Corporation – HSBC. Plans were passed in June 1907 but it was another two years before the bank opened here, eventually opening its doors on 8 February 1909. What is remarkable is that it has survived redevelopment on each side, the original building of Charter Place leaving one side more exposed than it originally was when a narrow passageway, Chequers Yard, led from the High Street at this point towards Beechen Grove. It has once again survived further surrounding development as recently as 2018. The architect was Thomas Bostock Whinney (1860–1926), who lived and worked in London and designed many banking premises throughout his career. He was a student of the Royal Academy and was made a fellow of the Royal Institute of British Architects. In 1895 he married one of Charles Dickens' granddaughters.

It differs from many of the surrounding and adjacent buildings as it was designed in the style with a single storey but has a somewhat sophisticated baroque revival design. Its frontage is faced in horizontal grooved Portland ashlar with a grandiose triumphant arch entrance front in a Roman style. The banking hall itself is built in stone, on a Greek cross plan. It is unique in style and almost looks out of place among the surrounding twenty-first-century introductions, yet holds its own place and remains an iconic building on this forever diversifying High Street.

The banking hall of the current HSBC bank.

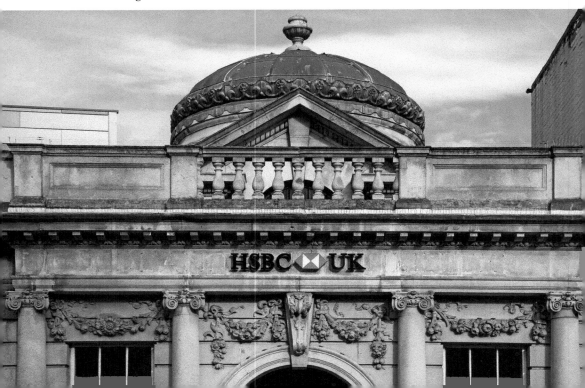

27. Watford Boys' Grammar School and Clarendon Muse

Situated on Rickmansworth Road, the school was built to house the boys from the former Endowed School in Derby Road. As a result of the changes in education brought about by the 1902 Education Act, more children were staying longer at school. Even after the girls had moved in 1907 from Derby Road to their own purpose-built school in Lady's Close, the school was overcrowded. A large site was therefore bought in Rickmansworth Road and the new boys' school was opened by Lord Clarendon in 1912. The architects were Sir Edwin Cooper (1874–1942) and Samuel Bridgman Russell (1864–1955), who went into partnership together in the early 1900s – a joint venture that lasted until 1912. Their partnership was incredibly successful in winning design competitions during this time, with national successes including the Law Courts in Hull, the Public Library in Middlesbrough, the Royal Grammar School in Newcastle and the Rochester Technical Institute. Cooper, in his own right, was a very distinguished architect. He was a fellow of the Royal Institute of British Architects from 1903, and later served on the RIBA Council, as well as serving as the president of the Incorporated Association of Architects and Surveyors. He was awarded his knighthood in 1923, made an associate of the Royal Academy in 1930 and was awarded the Royal Gold Medal in Architecture in 1931. His most famous work is probably the former headquarters of the Port of London Authority on Trinity

Watford Boys' Grammar School, one of the most well-known buildings in the town today.

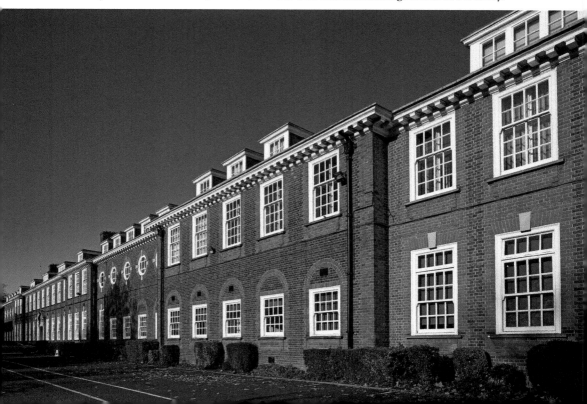

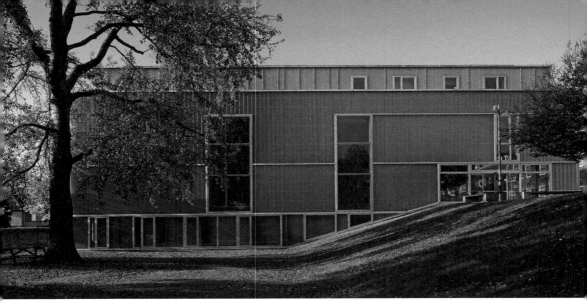

The new music centre in the grounds of the Boys' Grammar School.

Square in London. Russell also had a successful career, albeit one that did not reach the heights of Cooper's. He was also elected on to the RIBA Council but latterly worked more in a local authority context in Hitchin. For a number of years, he was the chief architect in the Ministry of Health. The school became more fully a part of the maintained sector and took up voluntary controlled status in 1944. In 1990, a greatly expanded Watford Grammar School for Boys became a grant-maintained school controlled by its own governing body, independent of the county council and funded directly by the Department for Education. The Boys' Grammar School remains popular to this day.

Adjacent to the Boys' Grammar School and within their grounds is the new music school, known as Clarendon Muse. The new music centre was designed by Tim Ronalds Architects, who are a London-based architectural practice specialising in the design of new arts and education buildings. Following the completion of the project, this spectacular building was rightly awarded a prestigious RIBA Award for Architecture in 2008. In addition, the building was the subject of a praiseworthy review by the *Guardian*'s architectural critic Jonathan Glancy in March 2008 and was subject to admiring assessments in a number of architectural journals. It is a bold design for Rickmansworth Road, an imposing landmark and wonderful contrast to the adjacent school building.

28. Former Cinema, King Street

One of the most important buildings in Watford is the former Essoldo cinema located on King Street. An attractive art deco style building, the original cinema was designed by the London-based architects Norfolk and Prior and was refaced as part of a comprehensive renovation during the 1930s, when the principal architect was George Coles (FRIBA) and the interior was remodelled

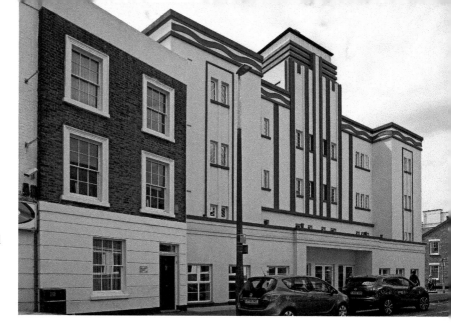

The former cinema, preserved and converted into flats and now a significant landmark in the town.

by Theodore Komisarjevsky. Its importance is notable because it was Watford's first large cinema, and played a significant part in the development of the town's leisure facilities. Originally known as the Central Hall Cinema, it opened on the 17 December 1913, but was renamed as the Regal in 1929 and eventually as the Essoldo in 1956. It ultimately closed as a cinema in 1968 and was used as a bingo hall for many years. Now converted to flats, the scale and design of the building is stunning and it forms an important part of the streetscape of King Street.

29. Moon Under Water Public House

The Moon Under Water public house has a fascinating history. A two-storey building located on the western side of the High Street, it is of architectural interest and retains many of its ornate features from it restoration in 1916. The restoration works were carried out by a Rickmansworth architectural firm called Swannell & Sly. The likelihood is that the building is much older, with the cellar probably predating the existing building. After the works of 1916, the previously named Derby House and its rear garden became The Empress Winter Gardens and Tea Lounge. Several decorative buildings to the rear associated with this business have since been demolished. The site was once considered suitable for the terminus of the Metropolitan Line station from Moor Park in the 1920s and the land was acquired for this use, with parliamentary approval given in 1929. This would have had a detrimental effect on Cassiobury Park but permission was denied by the borough council. However, the site ended up being leased for commercial purposes when it became clear that development would not be feasible. One of the finest details on the building is the projecting parapet above, which has detailing including two moulded medallions with the head of Queen Victoria, still very visible today.

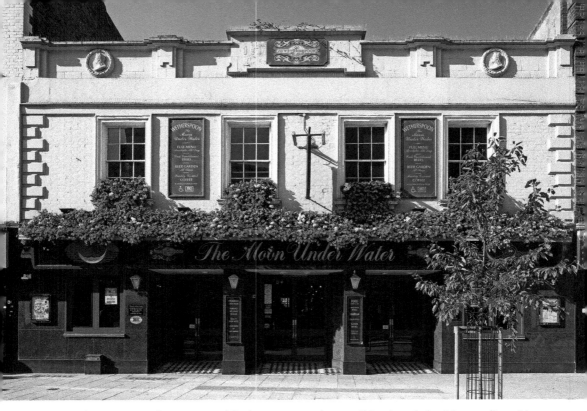

The Moon Under Water public house, once the possible site of the Metropolitan Line station extension showing the decorative features of the head of Queen Victoria.

3c. The Palace Theatre

Watford Palace Theatre was designed by architect H. M. Theobald. It was opened on 14 December 1908 for the Watford Hippodrome Co. Ltd and was known as the Palace of Varieties. Built on the site of a former meadow in Clarendon Road at a cost of £6,000, there was initially opposition from nearby local residents. It was extended in 1910 with a new façade of red brick with a tower at each end with a cupola. By 1911, further changes were made to the front of the building with over 300 lamps lighting the building and an auditorium for 1,000 people. Its opening night was a grand affair with the Watford Artisans Band playing the national anthem as the curtain rose. In the early days of the theatre, music hall acts alternated with plays and early films and from the beginning touring companies also visited. Variety artists who appeared included Marie Lloyd, Evie Greene and Lottie Lennox. In 1929, an application was made for a seven-day license in order to present Sunday League concerts at the theatre. There was some opposition, alleging that concerts would contain coarse jokes and rudeness. The license was granted on the grounds that the allegation was simply hearsay and nothing could actually be proved.

By the 1930s weekly repertory was established, which continued during and after the Second World War. For nearly ten years around the early 1960s, actor and writer Jimmy Perry was owner and manager at the Palace, who was best known for co-writing the comedy sitcom *Dad's Army*, It Ain't Half Hot Mum and Hi-De-Hi. By 1965 the theatre was in financial difficulties and with the backing of Watford Borough Council, a Civic Theatre Trust took over the building. In September 2004, it was refurbished after an £8.8 million lottery-funded program while retaining much of its original 'lively Renaissance style interior'. The front façade is of red brick and Bath stone, having been renovated in 2011.

Today the Watford Palace Theatre has a capacity of over 600 and throughout its history has been a music hall and variety theatre, a repertory theatre, as well as a civic theatre. It is the largest Edwardian theatre in the region and it continues to present a varied programme of plays and films to residents and visitors of the town.

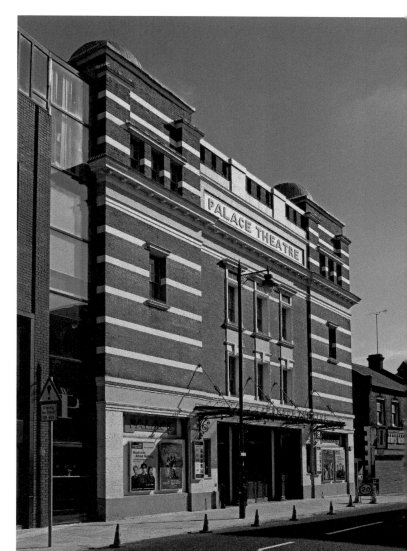

Watford Palace Theatre, once known as the Palace of Varieties.

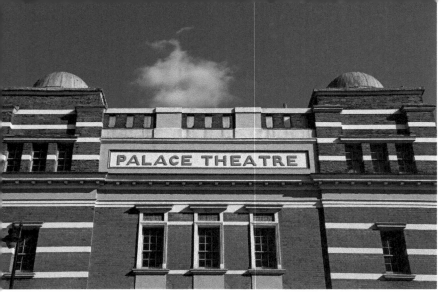

The theatre was extended in 1910 with a new façade of red brick and a tower at each end with a cupola.

31. Nos 62–70 High Street

On the corner of the High Street and Market Street is a three-storey timber-framed building that almost looks out of place in Watford. It has been described as 'Tudorbethan'. The building was designed by the London-based architects Charles Elcock and Frederick Sutcliffe. The partnership was responsible for a number of prestigious works elsewhere, and in particular the *Daily Telegraph*

The site of the former Compasses public house, now occupied by a 'Tudorbethan' timber-framed building.

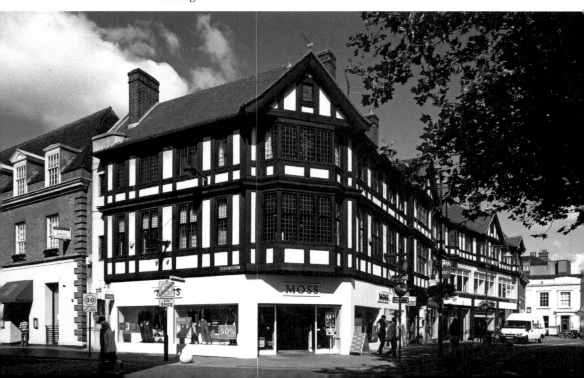

This timber-framed window, dating from the fifteenth century, was possibly part of the rest house that was located here, serving those attending Watford Market.

premises on Fleet Street. This building dates from the 1920s, but parts are much older. The Compasses public house, which was first founded on this site in the early eighteenth century, was situated on the corner of the High Street and Market Street. When it was partly demolished the elevation onto Market Street was found to contain a timber-framed window that dates from the fifteenth century and is believed to have been part of the rest house that was located here, serving those attending Watford Market. The window is still visible to this day.

32. Watford Football Club

Vicarage Road is one of the most well-known streets in Watford but also throughout the football world. Vicarage Road is the home of Watford Football Club. The beginnings of the football club can be traced back to 1881, when Watford Rovers was formed by Henry Grover and a group of fellow teenagers who had been given permission by the Earl of Essex to kick a football around in Cassiobury Park. Friendly matches began in 1882, with various sites in the town being used for matches. The first competitive game was an FA Cup tie against Swindon Town in 1886. In 1890, West Herts Club and Ground was set up in Cassio Road and Watford Rovers moved in as the football section, changing its name to West Herts in 1893.

Regular league football began when West Herts joined the Southern League Division 2 in 1896, and the club turned professional the following year. In 1898, the rival town club Watford St Mary's was absorbed, and the club's name simply became Watford. Watford were eventually promoted to the Southern League Division 1 as champions in 1900, and soon became regarded as one of the leading clubs in the south of England at this time. Operations were suspended during the First World War, and restarted in 1919 with the local Benskin's Brewery as the club's benefactor – an association that would last over forty years. In 1920 Watford became members of the Football League when the Southern League joined en masse.

It was at this time Watford FC needed to relocate, eventually moving to Vicarage Road in 1922 after it had been playing for twenty-three years at the ground on Cassio Road. The club played their first match at the new ground on the 30 August 1922 against Millwall. However, the mid-1920s was a troubled period. By 1926 the club was in financial crisis, caused by the costs of the move, and launched a public appeal.

Vicarage Road back then consisted of two small covered stands and several terraces. One of these stands, the Union Stand, had been brought from Watford's previous round on Cassio Road. Around a decade later, the Union Stand got replaced by a new stand – the Shrodells Stand.

Further developments to the ground were made in the 1950s and 1960s, including an extension to the main stand in 1969. The Shrodells Stand was again replaced by a new stand in 1986. The new Rous Stand consisted of two tiers and introduced corporate facilities to the ground. In 1993 and 1995, following the Taylor report recommendations, two new stands were built at both ends. This only left the original main stand from 1922 and its extension in place. After the original part of the main stand had already been closed in 2004 following safety concerns, it was demolished in 2010 as a result of further doubts regarding the state of the stand. Plans were made for the construction of a new stand, which got delayed until 2014 when the new Sir Elton John Stand opened. Soon after, following the promotion of Watford to the Premier League, the stand got expanded with additional rows of seating towards the pitch. With a capacity of just over 21,000 in 2018, the club remains ambitious, with plans being considered to increase to 30,000, with the club flying high in the Premier League.

Vicarage Road, the home of Watford Football Club since 1922. (Photo courtesy of Andrew Lalchan)

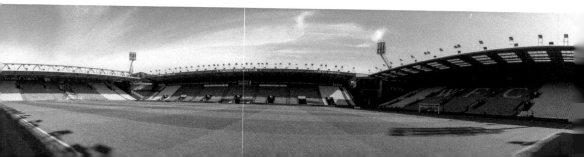

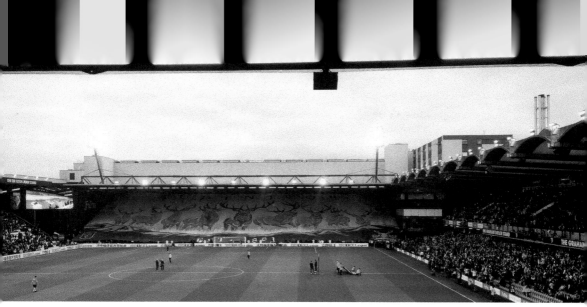

Above: Match day at Vicarage Road. (Photo courtesy of Helen Smith)

Right: Vicarage Road has been extended and improved over recent years.

33. Watford Metropolitan Line Station

The underground link to Watford is of considerable significance to the town, and if it had fulfilled its potential of a direct link to the town centre, Watford may have taken on a much different character. As it happened, it got no further than Cassiobury Park Avenue. The Metropolitan Railway was the world's first underground line, and opened in 1863 to ease considerable and growing traffic congestion and to provide a passenger link between London's main northern railway termini at Paddington, Euston and Kings Cross. From the late 1860s the Metropolitan began to expand gradually through the northern suburbs and into the countryside beyond, where the company reaped large profits from the development of commuter housing. By 1880, Harrow was reached and Rickmansworth in 1885, with the line eventually extending even as far as Aylesbury in Buckinghamshire. A number of branch lines diverged from the main trunk route. One of the most ambitious of these, first planned in 1912 but not opened until 1925, ran from Moor Park via a series of cuttings and bridges to Watford. The suburban terminus was built by the Metropolitan's in-house architect Charles Walter Clark, and it was the borough council's refusal to allow track to be laid across Cassiobury Park that meant that the previously referred to initial plan to bring trains through to the High Street and the town centre had to be abandoned – thankfully. The station itself has seen very little alteration. The architect designed around twenty-five new and rebuilt stations for the Metropolitan Railway between 1910 and 1933, as part of the renewal programme that accompanied the railway's electrification. Clark employed a grandiose classical

Watford Metropolitan Line station.

style for the company's Central London properties. For out-of-town stations such as Watford, he developed a brick-built domestic revival manner, intended to evoke the local rural vernacular and set the tone for ensuing suburban development; as well as Watford and its neighbour and contemporary Croxley, this is also evident at Stanmore and Kingsbury (both 1932) on what is now the Jubilee Line.

Watford station remains the most complete surviving example of this distinctive group of suburban Metropolitan Line stations, with Clark's 'homely', vernacular design and features such as its original tiling. The design epitomises the aesthetics of 'Metroland', an interwar movement to the rural suburbs named by John Betjeman, that captured large parts of the nation's architectural imagination.

34. Monmouth Place

One of the most prominent buildings on The Parade is Monmouth Place, a row of six premises originally intended for retail, with mixed uses above. The building was designed by the London and Watford-based architects John Moore Smith (FRIBA) and Henry Colbeck (FRIBA), who designed and lived at Cheslyn House. The building is another excellent example of 'Tudorbethan' design and it has often been rumoured that they used reclaimed materials from the demolished Cassiobury House. Certainly, the chimneys appear as if they have originated from elsewhere and are similar in style to other buildings on the Cassiobury estate.

Monmouth Place on The Parade, built possibly with reclaimed materials from Cassiobury House.

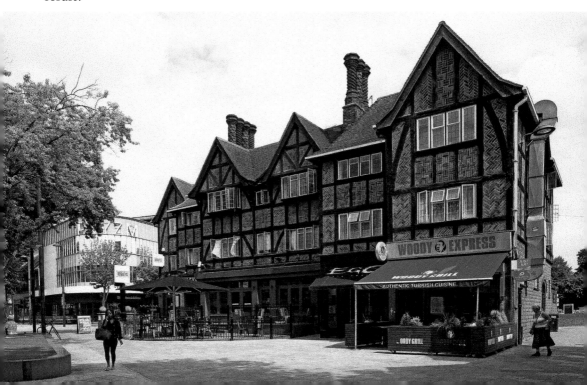

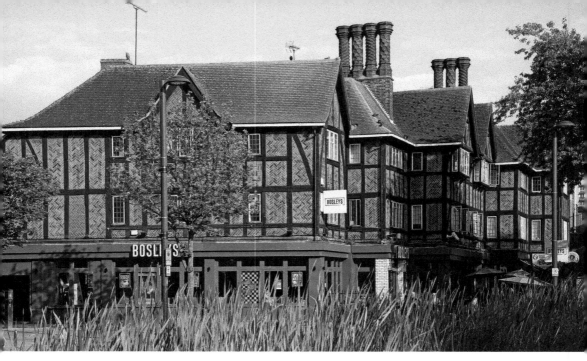

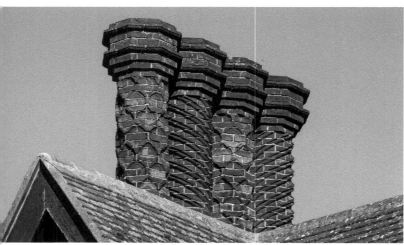

Above: Monmouth Place from the pond on The Parade.

Left: Chimneys on Monmouth Place, and possibly from Cassiobury House, demolished in 1927.

35. The Peace Hospice and Peace Centre

The Watford and District Peace Memorial Hospital on Rickmansworth Road was opened in June 1925, at a cost of £90,000, by the Princess Royal. It was built to replace the old Cottage Hospital on Vicarage Road but the new hospital eventually was also under the same intense pressure for more space. Further extensions were added here and a further appeal raised £70,000, also by public subscription, including a new ward and nurses' home opened by the Duke and Duchess of Kent, which came to be known as Knutsford House on 27 October 1937.

The main hospital was designed by the architect Wallace Marchment, who specialised in the field of hospital architecture – where he won a number of competitions. It was financed with funds raised by local donations, and the current surviving building is all that remains of a much larger complex of buildings that made up the Peace Memorial Hospital. After sixty years of service to the local community, the hospital was closed in 1985 and amalgamated with Watford General Hospital. Amid public outcry about the dismal state of the hospital, the South West Herts Hospice appeal was launched in 1991 from an office above the Watford Hospice Shop in the Lower High Street. The two campaigns gradually came together, with enthusiastic backing from the *Watford Observer*, and in 1992 the Health Authority agreed to a hospice on the Peace Memorial site. By 1993 the hospice appeal had raised enough money to start a temporary daycare centre in a portakabin alongside the hospital. It was opened by entertainer and hospice campaigner Roy Castle. The next target was to transfer the daycare centre and office facilities into the old hospital. Building work began in 1995, and the new facility was officially opened by Princess Michael of Kent the following year. The princess returned five years later to open a new inpatient unit with eleven beds. In 2008 two further inpatient rooms were provided.

Princess Michael of Kent was to return again in 2011 to open a further extension to the hospice facilities. The old shell, formerly a first-floor storage area at the back of the building, was fitted out to provide rooms for counselling and complementary therapy, as well as an en-suite family room.

The Peace Memorial Hospital.

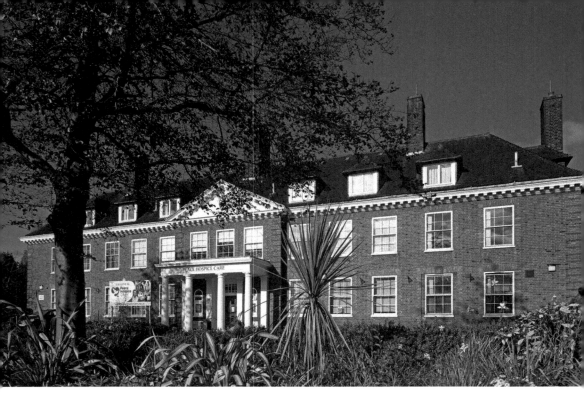

Above: The Peace Hospice, financed by local donations and opened in 1925.

Below: The clock over the front porch was donated by Alexander Hicks, licensee of The Rose & Crown Hotel, Market Place, and was installed between May and November 1931.

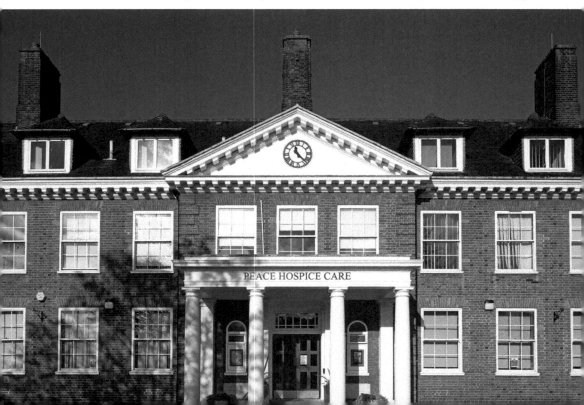

Watford's Peace Children's Centre, adjacent to the Peace Hospice and in stark contrast to the older building.

36. Central Library

Watford Public Library and School of Science and Art opened in 1874 in Queen's Road, and was a building provided by public subscription on a site given by Mr Thomas Clutterbuck. A prospectus dated 1923 shows that the school offered a wide range of classes in fine art, commercial art, crafts such as art, needlework, embroidery and lace; and trades including process engraving, house painting and decoration, typography, and millinery. Other subjects ranged from bookkeeping to typewriting. The continued work of the library demanded much more space and as a result new premises were required. Built in 1928 as the town's new principal library,

Watford Central Library.

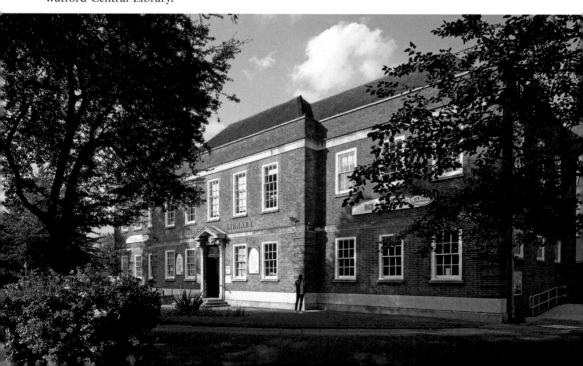

the current building eventually replaced the building on Queens Road, which became purely educational. The new building is a good example of municipal scale architecture from the interwar period and retains most of its original features. It was designed by the borough architects H. A. Gold (FRIBA) and W. W. Newman (LRIBA). It was built by the local contractors Messrs Charles Brightman & Sons Ltd, who were responsible for the construction of most of the Cassiobury estate. It was eventually opened by Sir Frederick G. Kenyon, director and principal librarian of the British Museum. Originally only the lecture hall was upstairs but the building was extended in the 1950s to complete the façade and again an additional storey was added to the side and rear wings between 1961 and 1963 to designs by the municipal architect F.C. Sage (AMICE). It remains the town's principal library.

37. Rembrandt House

Located on the north side of Whippendell Road between the junctions with Hagden Lane and King George's Avenue, Rembrandt House is a former factory building that was designed by the London-based architect Henry J. Wise. It was one of his principal works as an architect, and was built in the early part of the twentieth century for the industrialist Robert North, who lived in the house, also designed by Wise – 'St Wilfred's' – to the rear of the factory. The building was

Rembrandt House, a former factory converted to flats.

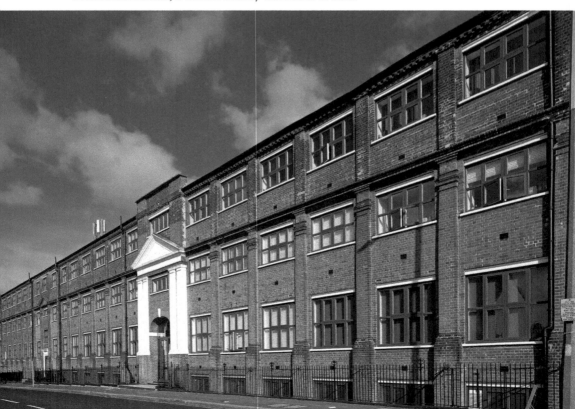

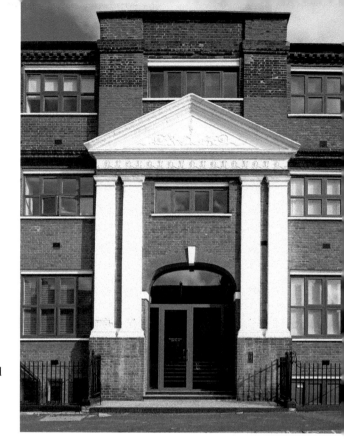

Right: Rembrandt House and its grand entrance from Whippendell Road.

Below: An excellent conversion from industrial into residential.

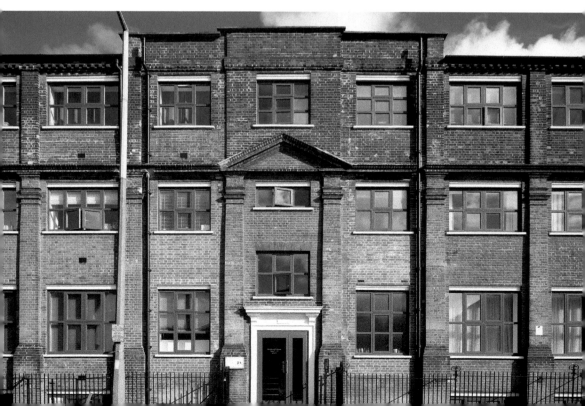

originally Neilsons' Watch Factory, and then it became North & Sons, and The Watford Speedometer & Magneto works through the 1920s and 1930s, which went into liquidation in the depression of 1928–30. In 1934, it also housed Rembrandt Photogravure Ltd works, which were related to the Sun Engraving Company, and from which the building got its name. Thankfully, the building was saved and is now wholly residential, incorporating thirty apartments.

38. Lanchester Building

The original library on Queen's Road had moved out into purpose-built accommodation on Hempstead Road in 1928, but the remaining use for classes was still not sufficient. Plans for a new technical college were proposed in 1935, to be built near the town hall on Hempstead Road. Known as the Lanchester Building, this was built as Watford College, and construction work started in 1938. However, the outbreak of the Second World War delayed the project such that it was not completed until 1953. During the war, it was used as a government training centre. Despite still not being completed, in 1948 the technology department moved in and was also joined by a newly formed printing department in 1950 before its ultimate completion. The building was designed by the distinguished architects Dr Henry Vaughan Lanchester (FRIBA) and Dr T. A. Lodge (OBE and FRIBA), who were responsible for a number of nationally listed buildings elsewhere. Among many achievements, Lanchester was the recipient of an RIBA Gold Medal and was president of the

The Lanchester Building, formerly Watford College and now a primary school.

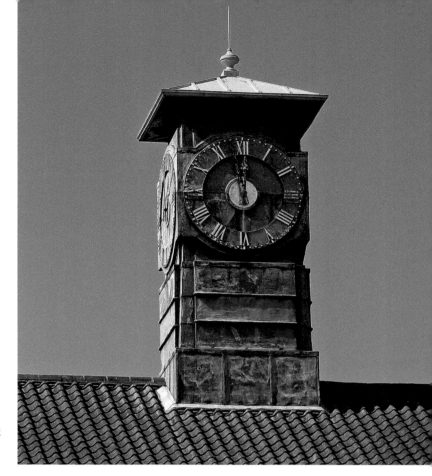

The impressive clock tower above the Lanchester Building.

Town Planning Institute for a number of years. It was opened by Lieutenant-General Sir Ronald M. Weeks on 15 May 1953 and eventually became known as Watford Technical College until a new college complex was opened nearby in 2010. Having stood empty for a number of years, it was reopened as a primary school in 2016.

39. Nos 151–153 The Parade

Another fine original bank at the top of the town is the classical former Westminster Bank, which opened in 1930, at the time that this part of The Parade was being developed for commercial purposes. When it was no longer required by the eventual National Westminster Bank, it was converted into a public house known then as 'The Bank'. Externally, the decoration has been altered many times. Built in a classic style of Portland stone, the building was designed by the architect Septimus Warwick (1881–1953), who is most famous for his work in London, where he designed the Wellcome Building on Euston Road and was involved in the development of Canada House. Today it remains as a popular public house and bar.

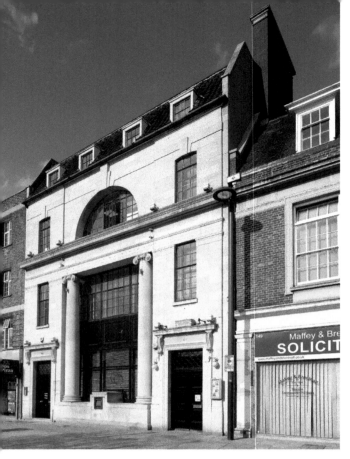

Left: The former Westminster Bank on The Parade, now a popular bar.

Below: Designed by architect Septimus Warwick, the building is in a classic style of Portland stone.

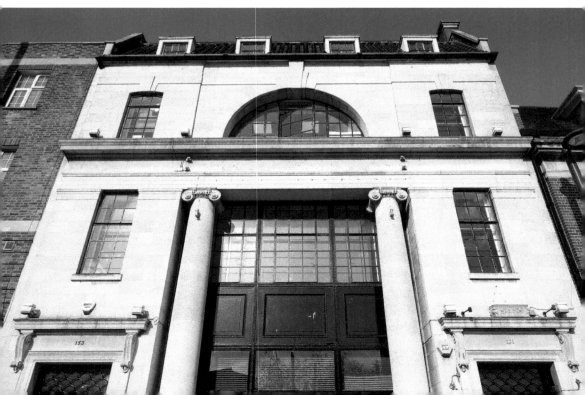

40. Watford Town Hall and Colosseum

Watford Town Hall was designed in 1935, and built between 1937 and 1939 by architect Charles Cowles-Voysey, and assisted by John Brandson-Jones and Robert Ashton. Cowles-Voysey was the master planner, and John Brandon-Jones did much of the detailed design work. Built at a cost of £186,000, these new municipal offices were built on the site of 'The Elms', which was once known as 'Town End House', an early eighteenth-century mansion that had previously occupied a position on one corner of the former crossroads at the top end of the town.

For several years, at first the urban district council, then followed by the borough council, had operated from offices in Upton House on The Parade. The council had bought The Elms in 1919, and the Peace Memorial Hospital was built on part of it in the 1920s. For a number of years, the council considered converting the house, then let, to municipal offices, but finally decided to commission a purpose-built town hall. The Elms was eventually demolished in 1937, and the foundation stone for the new town hall was laid in May 1938 by Mayor T. Rigby Taylor. The building was at an advanced stage when the Second World War started and permission was required for the work to continue. The building was officially opened in 1940 by the Countess of Clarendon.

The Town Hall itself has a number of principal rooms, which are highly decorative, inventive, and survive remarkably complete. Its staircase hall is made

Watford Town Hall
by architect Charles
Cowles-Voysey.

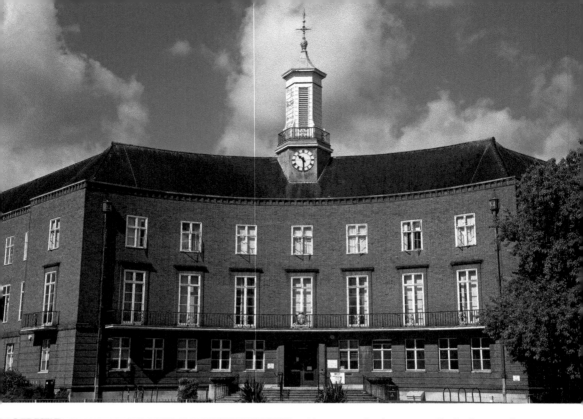

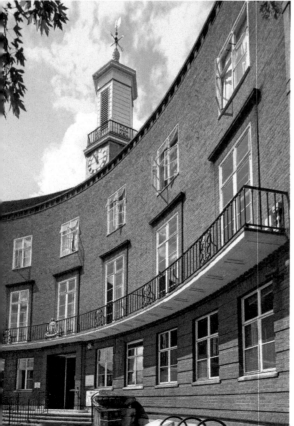

Above: Watford Town Hall, the home of Watford Borough Council since 1940.

Left: The building was officially opened in 1940 by the Countess of Clarendon.

of panelled stone, and has an imperial stair rising between square columns with an embellished bronzed balustrade incorporating stylised female figures – it is simply stunning. The council chamber is also remarkable for the survival of its original woven acoustic panels, set between bands of hardwood veneer.

Previously known as the Assembly Hall, the adjoining part of the building is now known as Watford Colosseum, and remains a prominent local venue for the arts and entertainment and is nationally renowned for its acoustic qualities. The building has been used for the recording of a number of film soundtracks including the *Sound of Music*, the *Lord of the Rings* and the *Star Wars* trilogies.

The panel on the left facing the building contains an abacus. It symbolises accountancy and everything appertaining to official routine. The book has 'alpha' and 'omega' on it, meaning 'all is reported from beginning to end'. On the centre panel there are instruments of labour, set-square, trowel and compass, symbolising planning and building. On the right-hand panel there is a violin, drum, etc., which suggests the social side of the town hall.

In 2010, the council commissioned RHWL Architects for a £5.5 million restoration and technical upgrade of the Colosseum and its art deco concert hall, with the addition of new foyer space. Their scheme enabled the venue to host a wider variety of performances and events and included a new and updated restaurant with bar facilities, as well as spaces for seminars and meetings during the day. The upgrading of the concert hall was minimal in order to retain its

The former Assembly Hall, now Watford Colosseum with its three brick panels.

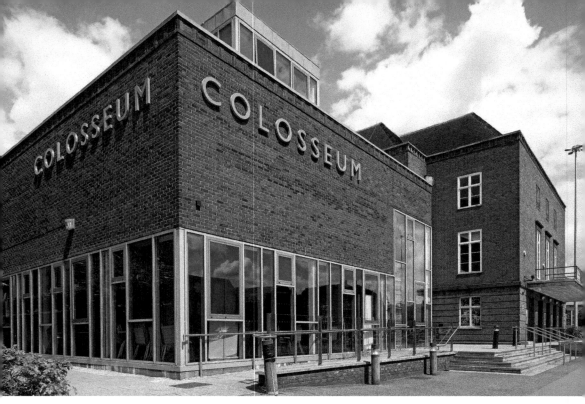

The Colosseum extension from 2010.

acoustic qualities. The worn timber linings and organ screen surround were fully restored. Included was a new colour scheme, which was adopted to reflect its range of uses. The successful extension building featured contrasting grey brick façades to the original building and large areas of coloured glazing and forms an imposing building between the original Assembly Hall and the adjacent Peace Hospice.

41. Police Station and Magistrates' Court

Located on the western side of Clarendon Road, between the junctions with St John's Road and Shady Lane, is the current Watford police station and magistrates' court. The building was designed by the Birmingham-based architects Samuel Nathanial Cooke and Walter Norman Twist, who won the commission following a national competition. The building was nationally recognised at the time and was featured in a number of architectural journals during the 1940s. The building was purpose-built in 1939 and opened in October 1940 at a cost of £70,000 as Watford's main police station and magistrates' court, replacing a smaller existing facilities elsewhere in the town centre. It has served since then as an important public facility. The West Herts Post reported at the opening that it was 'In quite a central position ... a worthy addition to the public institutions of the Borough. It is admirably designed to meet a need that had become more pressing as the population grew.'

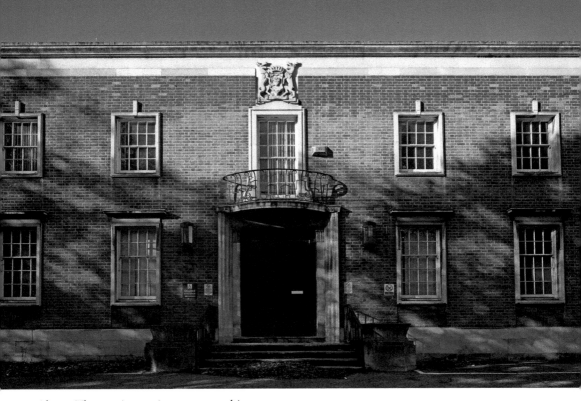

Above: The magistrates' court opened in 1940.

Below: The police station, present here for over seventy-five years.

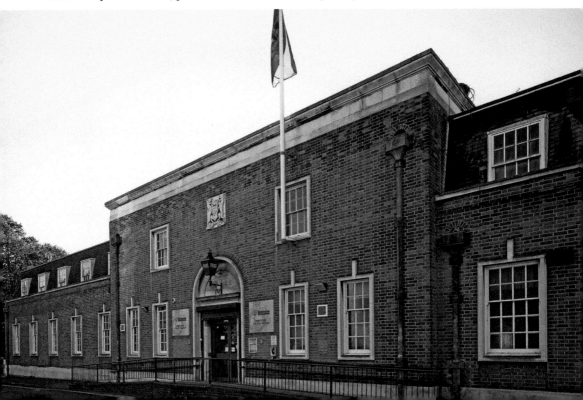

42. Cheslyn House

Cheslyn House, situated in the heart of Nascot, was designed by the local architect Henry Colbeck for his own use in 1949. Colbeck was a founder of the architectural practice Ley, Colbeck & Partners, which had offices in Watford and London. The house was the first to be developed on this plot of land, by Henry and his wife Daisy Colbeck. In 1965, the property and its grounds were sold to Watford Borough Council, who managed it in partnership with the Colbecks until the death of Henry in 1971. The house is still used by the council as a venue for meetings and the grounds are accessible as a public garden, which was awarded a Green Flag in 2009 and has every year since then, thanks to the careful management of the onsite gardener. The house is situated at the heart of these award-winning exotic gardens, which are of incredibly high horticultural value, giving the appearance of a botanical garden. With public art, lush planting, a woodland walk, a popular aviary and water feature, Cheslyn House and gardens are a hidden gem.

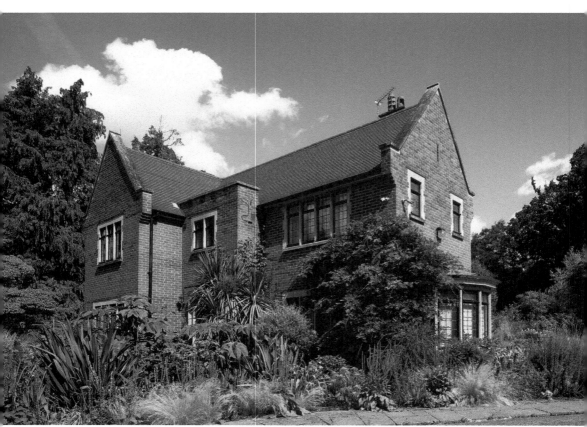

Cheslyn House, the former home of local architect Henry Colbeck.

43. Former Odhams Press Hall

Odhams (Watford) Ltd was a pioneering printing company. Established in 1935, it was located in North Watford on the site where ASDA is currently located. When building began here in 1935, the area consisted of fields, and the arrival of Odhams transformed not only the site, but also the neighbourhood, as houses, shops and schools were built to serve the expanding workforce. Just over twenty years later, after arriving in Watford, Odhams was described as 'one of the largest and most modern photogravure factories in the world, standing as it does on a 17½ acre site and employing nearly 2,500 work people'. It was established principally to undertake high-speed colour photogravure printing of magazines, but it also had letterpress machines, which printed trade publications, magazines, catalogues and books published by its parent company, Odhams Press, as well as other publishers.

Periodicals printed at the Watford works in the early years included *Woman*, a new colour magazine started in 1937, *Mickey Mouse*, *Picturegoer*, *Zoo*, *Mother*, *Illustrated*, and *Everywoman*. The volume of work was such that another factory block was built, which was started in 1937 and in operation by 1939. During the Second World War, Odhams (Watford) printed millions of leaflets, including those dropped on Germany at the beginning of the war, and those produced for D-day, plus the US Army publication *Yank*, and magazines for the French, Dutch and Italian liberation forces. After the war, Odhams (Watford) continued to expand its plant and activities.

By 1966, Odhams (Watford) was said to be 'one of the largest installations in the world', with over 6.5 million gravure periodical copies produced per week. In the 1970s, Odhams (Watford) was still the largest gravure printing plant in the UK. By 1974 it employed 2,800 people, and magazines printed there included *Woman*, *Woman's Realm*, *Woman's Weekly*, *Popular Gardening*, *Goal* and *Farmers' Weekly*. Nevertheless, Odhams made losses throughout the 1970s. There was a serious dispute in Odhams in 1974, which had a significant effect on profitability of both printing and publishing. Also, in 1975, proposals to merge Odhams with Sun Printers of Watford were defeated, only to be followed by some 200 redundancies. In 1981 there was jubilation at Odhams (Watford) when it won the multimillion-pound contract for the new *Sunday Express* colour magazine, but disaster was just around the corner. In 1981, Robert Maxwell became chief executive and deputy chairman of the British Printing Corporation, which owned Sun Printers in West Watford, a competitor of Odhams (Watford). Meanwhile, despite the new *Sunday Express* magazine contract, Odhams was in serious financial trouble, posting a trading loss of £5.5 million in 1981, and there were hundreds of job losses. At the end of 1982, Robert Maxwell bought Odhams from Reed International for £1.5 million. This included not only the factory, land and machines, but also print orders, including IPC titles and the *Sunday Express* magazine, worth £30

million per year. As soon as Maxwell bought Odhams, he boasted that he would close it in nine months, and this he proceeded to do, a process completed in September 1983 with the loss of hundreds of jobs, albeit achieved by voluntary redundancy. Around 400 Odhams' employees transferred to Sun Printers, which now officially became Odhams-Sun Printers, in Whippendell Road, but within a few years this also closed.

All that remains today is the former press hall, this building being designed by the London-based architectural practice of Yates, Cook and Darbyshire and is modelled on Stockholm Town Hall. The Press Hall building was purpose-built between 1954 and 1957 as an extension to the existing Odhams Printing Works, which had been built to designs by Sir Owen Williams. No longer part of the Odhams business, this 1950s building dominates views in the northern part of Watford, forming a key landmark in the town.

Odhams Watford Ltd, which had over 2,500 employees at its height in the 1950s.

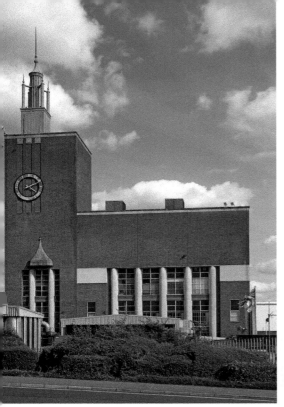
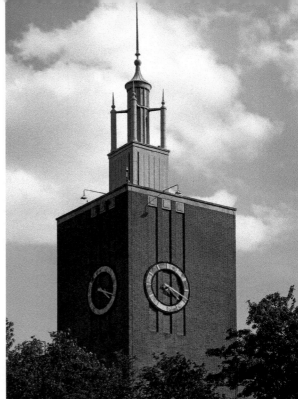

Above left: The former Odhams Press Hall.

Above right: The striking Press Hall was built in 1954 and the innovative clock tower housed a water tank for use in the printing process.

44. The Sugden House

This five-bedroom house is set in a tranquil plot and is just under half an acre in size on Devereux Drive. It was designed in 1955 by the celebrated architects Alison and Peter Smithson. It was given a Grade II listing by Historic England, who describe the Smithsons as 'one of the most influential [architects] of the post-war period nationally and internationally' and acknowledge the house as a very rare example of a completed domestic commission by the pair. The house was designed for Derek and Jean Sugden. Derek, an acclaimed acoustic engineer at Arup, was responsible for the acoustics of Snape Maltings, Glyndebourne, Theatre Royal Glasgow and concert halls at the Barbican, Bridgewater and the Jacqueline du Pré Music Building among others. Sugden's oft-quoted brief to the Smithsons was for 'a simple house, an ordinary house, but that this should not exclude it from being a radical house' and radical it is.

The Smithson Partnership was one of the most globally influential of the post-war period. The husband and wife duo, then aged just twenty-six and twenty-one, came onto the architectural scene in 1950 after winning a competition to build a secondary

school for 450 pupils on the edge of Hunstanton in Norfolk. Other projects have included the Economist Building in St James's Street, Robin Hood Gardens in Tower Hamlets and numerous university buildings in Bath. The building has been praised for the 'subtle nuances of design' and in particular the 'cheeky L-shaped windows in asymmetrical locations dictated by function rather than aesthetics' – found within the 'superficial simplicity of the exterior', which on first sight resembles an unremarkable suburban home. The simple ingenuity of the layout, which remains open plan but denotes the different use of spaces through levels, cupboards and curtains, was also revered, as was the imaginative use of materials both inside and out, from second-hand London stock bricks and dark red tiles to exposed concrete beams and Columbian pine joists. Notable interior fixtures include the open timber staircase and built-in storage designed by Alison Smithson, and a freestanding brick fireplace with a concrete lintel. Extensive glazing throughout the house floods it with light, while underfloor heating keeps it warm in the colder months.

Peter St John is among the many architects who have admired The Sugden House, calling it 'a loving interpretation of the Arts and Crafts house with Fifties builders' details, so witty and wonderful it makes me laugh'.

One of Watford's least-known architectural assets is the Sugden House, designed by Alison and Peter Smithson.

45. Former Cinema and Nightclub

The 'pictures' were the dominant entertainment in the 1920s and beyond. Watford was to have a number of cinemas including the (New) Plaza in St Alban's Road, which had been opened as the Electric Coliseum in 1912. It was known locally as the 'fleapit' and financially was not a success, eventually closing and reopening as the New Coliseum. The Empire was opened in 1913 and the Regal/Essoldo opened on King Street, known originally as the Central Hall Picture House. The former Empress Tea Rooms became the Bohemia Cinema but only lasted a month. The Super Cinema (Carlton) in Clarendon Road emerged as a result of the decline in roller skating.

However, it was a new cinema that opened just across from the town's most famous landmark. Overlooking the pond is an unusual but now modern building that has seen many changes over the years. It was originally the site of one of the town's cinemas, The Plaza, which opened here in May 1929 with *The Singing Fool* starring Al Jolson, the first 'talkie' to be shown in the town. It became the biggest in Watford with 2,060 tip-up seats. It was taken over by the Odeon Circuit in 1936 and renamed accordingly. It eventually closed in 1963 and by 1964 the rather grandiose building was demolished and made way for a ground-floor supermarket and Top Rank Suite nightclub.

Undergoing a number of ownership changes including the Destiny nightclub, the iconic Oceana, it is now the Pryzm nightclub.

Watford Odeon cinema, formerly the Plaza, *c.* 1937.

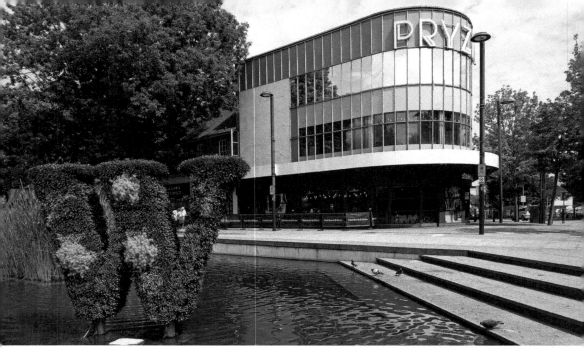

Overlooking a restored pond is Pryzm nightclub.

46. The Meriden Tower Blocks

A strange choice for *Watford in 50 Buildings* perhaps, but the Meriden tower blocks dominate the north Watford skyline and have done since the mid-1960s. In 1967 The Watford Local Directory described the area as 'Another excellent estate is that at Meriden. Here, houses of several designs and types have been built in a setting where open spaces have been created and many fine trees left standing to add a natural touch to the scene. It is on this estate that the council has built the town's first multi-storey blocks of flats. These well-designed blocks have become landmarks on the town's northern side and, of course, they give tenants not only every amenity of modern living but also a superb view out into the countryside around the town.'

The wonderfully named Meriden has a rich and vibrant history, and was first purchased by the Acquisition of Land Housing Committee on 12 June 1952 for a sum of £7,291, with a view to developing new homes. It wasn't until 1953 that the area took its current name as it was originally known as the Munden estate, but was changed after a request from Lord Knutsford, as this was also the name of his own estate and lands. After a consultation with the borough librarian, it was agreed that the new estate would be known as Meriden, reverting back to the name the area had formerly been known by in centuries past.

The very next year saw the appointment of the first contractors to work on the Meriden; Messrs A. E. Islip were contracted to build sixty new homes, with construction beginning in December 1954. It wasn't until ten years later in 1964, however, that construction began on the Abbey View and Munden View

tower blocks, and although they now dominate the Watford skyline, and are instantly recognisable to locals, they were originally going to be something quite different, with early plans calling for four twelve-storey towers to be built. These plans went through a number of changes in the years between the initial planning and construction, with eleven-, twelve- and fifteen-storey blocks being proposed before the final decision was taken to have seventeen storeys and only two blocks.

Truscon Ltd of London were awarded the contract, having submitted the lowest tender – £729,849 3s 8s, the equivalent of just under £14 million in 2018 money, a phenomenally ambitious project to undertake at that time. It wasn't until 28 February 1966, just a few short months before completion and the first residents moving in, that the towers were given the names Munden View and Abbey View in homage to Lord Knutsford's original Munden estate, and due to the spectacular view of St Albans Abbey to the east. The construction was not all plain-sailing though, with the project costing more than the initial estimate and overrunning by several months. Munden View and Abbey View were officially opened on 10 October and 31 October respectively, and the first residents were welcomed into their new homes.

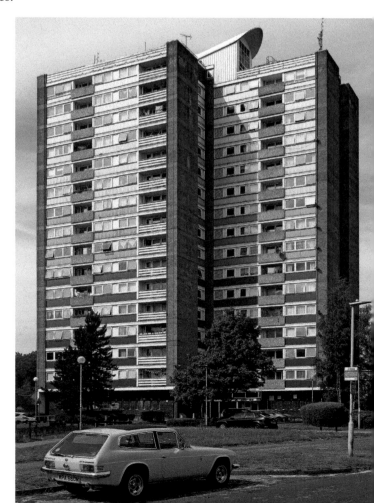

A classic car overlooked by a Meriden tower block.

47. Watford Central Leisure Centre and West Herts College Complex

The area by the Town Hall on Hempstead Road is one part of the town that has undergone significant and radical changes, transforming the face of education and leisure locally. Watford's public baths were sited here and were originally opened on 10 May 1933, and at the time it was thought they were the first to be electrically heated. Swimming before this time was only available in a lido facility on the River Colne close to the Five Arches railway viaduct. Swimming here was segregated between male and female so the move to the new baths was a welcome relief for many. After many years of use, the baths eventually closed in December 2006 as a major facelift was required. By August 2008 they were reopened to the public and remain a popular facility in the town.

As previously referred to the Watford Library and School of Science and Art began in 1874 on Queens Road and eventually moved to a new building on Hempstead Road called the Lanchester Building. The new college was located on part of the former Cassiobury estate, sold by the Earl of Essex. Watford Technical College was eventually founded in 1947 but it was not until 1953 that Watford Technical College was officially opened in its new premises.

By the 1980s Watford College of Technology merged with the George Stephenson College (built in 1965–66) to eventually form Watford College. West Herts College was later established in 1991 as part of the reorganisation of further education in Hertfordshire. It was created from the two local colleges – Watford College and Cassio College – and Dacorum College in Hemel Hempstead. A new Watford Campus building was constructed in 2010 and West Herts College vacated the Lanchester Building to take up its place next to the new leisure centre.

Watford Central Leisure Centre after a full revamp in 2008.

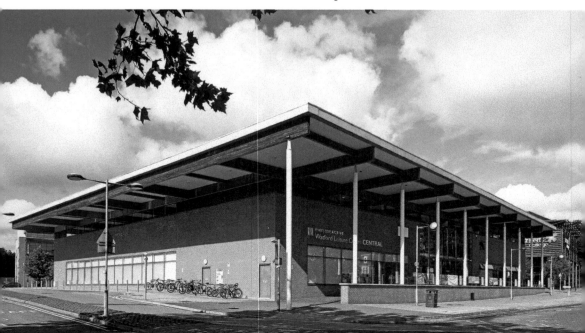

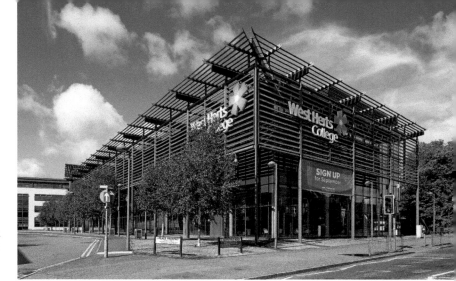

West Herts College, part of a major new complex on Hempstead Road, opened in 2010, two years after the new leisure centre.

48. Intu Centre and Charter Place

One of the greatest changes to the town was the building of the previously named Harlequin Centre. As part of this transformation a new shopping centre, which began in 1988, many private properties, both residential and retail, disappeared, along with a number of streets including Clifford Street, Carey Place, Charles Street and Albert Street. The new centre was completed in 1992 at a cost in excess of £100 million.

Further recent changes have once again dramatically altered the town centre with the expansion of the former Harlequin Centre, now renamed Intu Watford, and the redevelopment of the adjoining Charter Place. Watford's existing market was relocated to Charter Place in the mid-1970s but was once again relocated off The Parade in 2014 and rebranded New Watford Market as works began on redeveloping Charter Place. The stunning new complex was partially completed in 2018 and will continue into 2019 as units fill and commence trading.

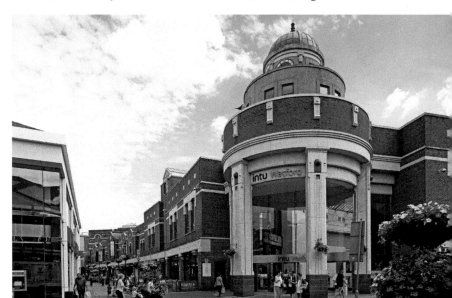

The former Harlequin Centre, now Intu Watford.

The Harlequin Centre and Charter Place, expanding in 2018 and has new units to let.

49. Seventh Day Adventist Church HQ

The Adventists have had a presence in Watford for many decades, and that continues to this day. Opened by them in May 1912, the Stanborough Park Sanatorium in Garston was 'modelled throughout on the latest ideas of sanitation and hygiene'. Practising hydrotherapy, the use of water for pain relief and treating illness, the sanatorium facilities also included physiotherapy, radiotherapy, a small operating theatre and a maternity wing.

On 14 November 1927, the foundation stone of the Stanborough Park Church was laid by the British Union president, Pastor W. H. Meredith. By this time Stanborough Park took in all of the area now occupied by the Kingswood estate, North Watford Cemetery, Purbrock Avenue and Spring and Holland Gardens and extended beyond what is now the North Orbital Road as far as Leavesden High Road. It was Dr. Rubel of the sanatorium who was the driving force behind the building of the church. He led the band of members working with forks, spades, pickaxes, shovels, saws and hatchets as they cleared the ground for what would become 'The Church in the woods'. After the foundation stone was laid all who had paid a shilling to do so laid a brick.

By 1931 the Stanborough Park grounds had shrunk considerably due to the taking over of the college farm to accommodate the building of Watford's North

The Seventh Day Adventist Church HQ for the UK and Ireland, and a modern building clearly making a statement.

Orbital Road so the Ministerial Training College was removed to the Palladian mansion of Newbold Revel in the English Midlands, but the removal of the college facilitated the development of the Stanborough Park Secondary School in the former college building, which was rehoused in a purpose-built unit in 1991. Everything also changed with the creation of the National Health Service in 1948. The decline in private healthcare meant that after suffering years of financial losses, the sanatorium finally closed in 1968.

Despite the closures, membership numbers were growing and larger additional space for church activities was required. The new millennium saw the construction of the Stanborough Centren, which met the needs of not only the church but also of the local community. Finally, July 2014 saw the beginning of an ambitious project to extend and refurbish the church to meet the needs of the twenty-first century. It was finally completed in October 2015, with an official opening ceremony performed by the elected Mayor of Watford on 6 November.

The presence of Adventists in Watford remains strong with the Stanborough Centre. However, also opened in 2011, was the Seventh Day Adventist Church headquarters in Stanborough Park, a £3 million replacement for the original building, which was almost completely destroyed by a freak blaze in 2008. The building is significant as it is now the church headquarters for the whole of the UK and Ireland.

50. Cassiobury Park, the Cha Tea Pavilion and Cassiobury Hub

The Cha Tea Pavilion dates from around 1926 and is an excellent example of period municipal architecture and a significant building in the historic Cassiobury Park. It is most notable for its squat round headed clock tower. Cassiobury Park was acquired over time by Watford Council between 1909 and 1930, as land previously belonging to Cassiobury House was sold off. The tearooms were constructed very soon after, although map evidence suggests that the building may have had other uses historically, such as being a day nursery. It was significantly rebuilt in 2000–01 following a fire, rebranded as a nursery but was soon reconverted into a tea pavilion once again. It has remained a popular facility in Cassiobury Park since then, with further improvements made in 2016 as part of a Heritage Lottery funded restoration.

In 2013, Watford Borough Council submitted a £5 million bid to the Heritage Lottery Fund for the restoration of Cassiobury Park, and with a further £2 million committed from the council, the scheme incorporated a new sustainable hub building designed by Knox Bhavan architects. This modern building, opened in 2017, now incorporates a new café in the park, education and community room, parks management office, toilets, changing rooms and underground storage for the paddling pools plant. With over 2 million visitors to the park every year and nearly 100,000 alone each season to the new paddling pools, the new award-winning hub nestles beautifully and sympathetically in the historic Cassiobury Park and is a great contrast to the art deco style of the Cha.

The Cha Tea Pavilion, dating from 1926, with drinking fountain.

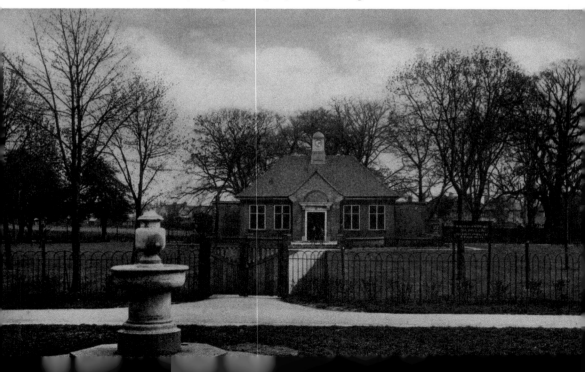

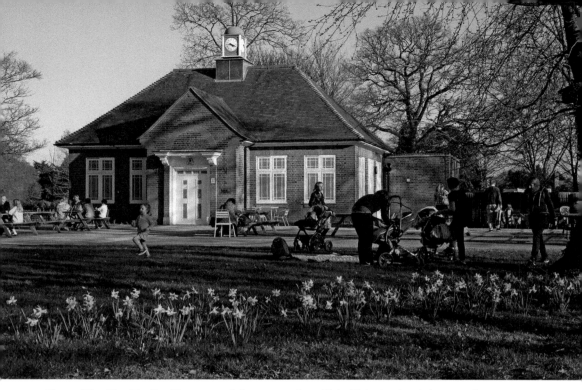

Above: The Cha Tea Pavilion, one of the two main café facilities in Cassiobury Park, was restored in 2017.

Below: Cassiobury Park paddling pools, originally introduced to the park in the 1930s, are fed by water from the River Gade and replaced with new pools in the 1980s. These were removed in 2016.

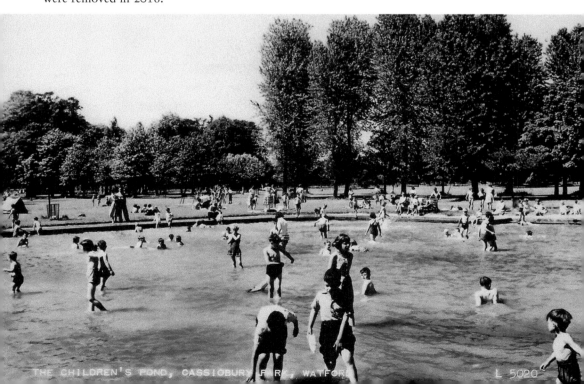

THE CHILDREN'S POND, CASSIOBURY PARK, WATFORD L 5020

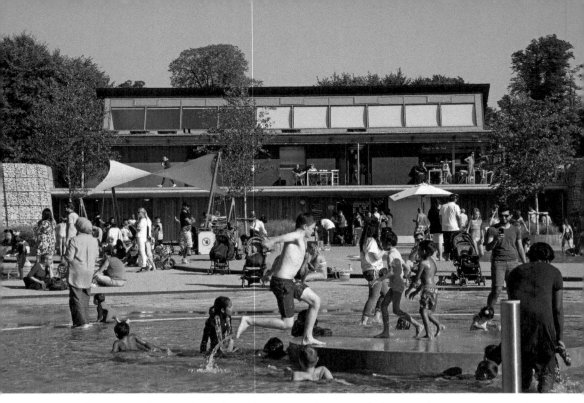

Above: Cassiobury Park Pools, with new award-winning hub, opened in 2017, a centre for managing the 2 million plus visitors to the park every year. .

Below: Cassiobury Park hub, a modern sustainable building for the twenty-first century.

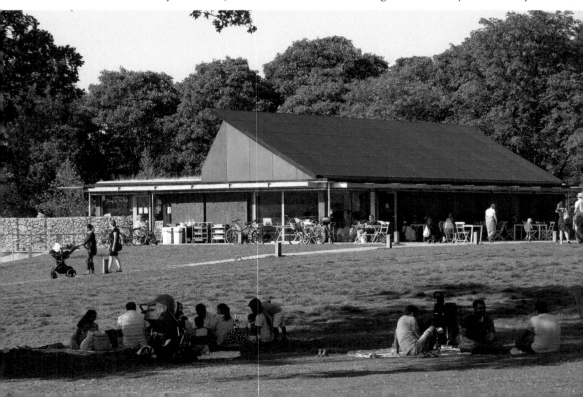

Bibliography

Author unknown, *More About Watford* (1973)

Ball, Alan W., *Watford: A Pictorial History, 1922–72* (Watford Borough Council, 1972)

Bard, Robert, *Watford Past* (Historical Publications, 2005)

Cooper, John, *Watford Through Time* (Amberley Publishing, 2011)

Cooper, John, *Watford History Tour* (Amberley Publishing, 2016)

Cooper, John, *A Postcard from Watford* (Amberley Publishing, 2012)

Edwards, Dennis, *Watford in Old Picture Postcards* (European Library, 1999)

Edwards, Dennis, *Watford: A Pictorial History* (Phillimore, 1992)

Forsyth, Mary, *Watford: A History* (The History Press, 2015)

Knight, Judith, *Watford: The Second Selection* (Archive Photographs)

Local Studies, Hertfordshire Archives, *Watford: Britain in Old Photographs* (The History Press, 2012)

Nunn, J. B., *The Book of Watford: A Portrait of Our Town, c. 1800–1987* (Pageprint Watford, 1987)

Nunn, J. B., *Watford Past: A Pictorial History in Colour* (Moorland Printers (Watford) Ltd, 1999)

Rabbitts, Paul, and Priestley, Sarah Kerenza, *Cassiobury, the Ancient Seat of the Earls of Essex* (Amberley Publishing, 2014)

Rabbitts, Paul, and Priestley, Sarah, *Cassiobury Park: The Postcard Collection* (Amberley Publishing, 2017)

Rudd, Helen, *The Old Almshouses of Watford* (St Alban's & Hertfordshire Architectural & Archaeological Society, 2013)

Saunders, W. R., *History of Watford* (Pageprint Watford, 1986)

Temple Trust, *A Brief History of Frogmore House, Watford* (leaflet undated, c. 2007)

Watford: A Pictorial Record (Festival of Britain Committee of the Borough of Watford, 1951)

Watford in the 20th Century, Volume 1 1900–1939 (Watford Observer, 2011)

Watford WEA, *Aspects of Nineteenth Century Watford* (October, 1987)

https://www.wcht.org.uk/meriden-estate-anniversary

http://www.stadiumguide.com/vicarageroad/

https://stanboroughpark.adventistchurch.org.uk/100years

Acknowledgements

Paul Rabbitts

As with any book, there are always a number of people to thank. I have thoroughly enjoyed writing this book with Peter and at the same time learning about the town where I work. The challenge was to choose the fifty buildings and there will be those that will question the list and ask why certain buildings were omitted and even included. Of course, I have to thank my co-author Peter Jeffree for all the fantastic images he has captured of this wonderful town and doing such buildings an incredible justice; Hayley Page, Paul Banks, and Helen Smith for spontaneously helping with the final shortlist when I was struggling to get down to the final fifty – no mean feat; eBay as a great source of historic images; and to all the many friends, colleagues, residents, and councillors who make Watford what it is today. All historic images are from the authors' own collections unless acknowledged otherwise.

Peter Jeffree

When Paul Rabbitts generously invited me to work with him on this book, I jumped at the chance. I had started photographing Watford's important buildings a few years before, but needed somewhere to make use of them and a publishing deadline to concentrate the mind. What amazed me was finding the number of lovely buildings and details that I had never noticed before despite living in Watford for many years. I hope readers will be equally surprised by the rich built heritage Watford has to offer. Thanks are due particularly to Paul for his research on the buildings and his excellent text. Also to Sian Finney-MacDonald whose conservation team produce the lists of historic buildings that were the starting point for my shooting list, and to my very tolerant wife who puts up with my obsession with the weather forecast and my random exits when I think the light is right for a particular shot.